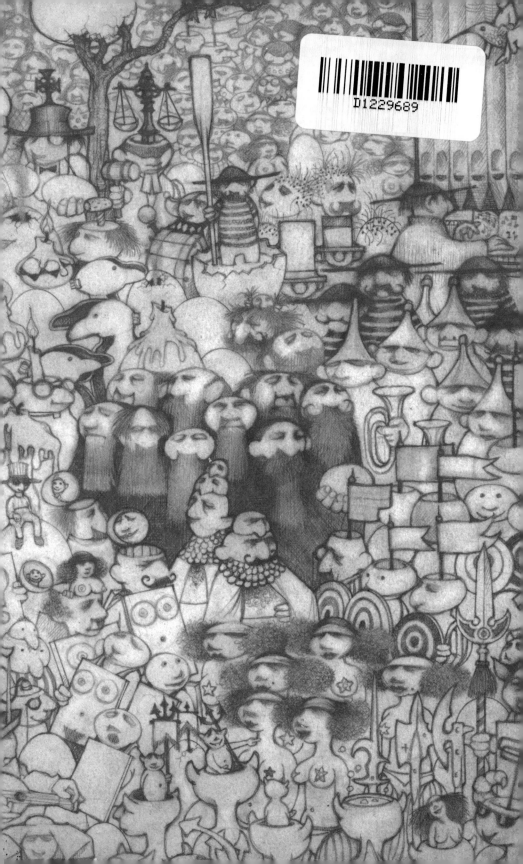

ASYLUM EARTH

To Steve,

all my very best

Charles Bragg

11·5·94

THE PAINTINGS

Ship of Fools, oil on canvas, jacket: Collection of Robert and Beverly Cohen,
Newport Beach, California

The Thinker, oil on canvas, page 3: Private Collection

The Fifth Day, oil on canvas, page 6: Private Collection

The Devil's Work, oil on canvas, pages 14-15: Collection of the Artist

Francis of Azusa, oil on canvas, page 19: Private Collection

Garden of Eden, oil on canvas, page 21: Private Collection

Graphite drawing, page 31: Collection of the Artist

The Observer, oil on wood panel, page 71: Private Collection

Waldo the Warthog, oil on panel, page 115: Collection of the Artist

Janus, oil on panel, page 119: Private Collection

The Procession, oil on canvas, page 126: Collection of the Artist

Thermo, graphite and watercolor, page 129: Collection of the Artist

The Liberator, oil on canvas, page 155: Private Collection

Great White Hunter, oil on canvas, page 166: Private Collection

Rover and Grover, oil on canvas, page 169: Private Collection

In the Beginning, oil on canvas, pages 202-203: Private Collection

Glasnost, oil on canvas, pages 222-223: Private Collection

Art Heaven, oil on canvas, page 233: Collection of Ben and Sue King,
Washington, D.C.

In the Beginning There Were Mistakes, oil on canvas, page 238: Private Collection

Rembrandt and Model, oil on canvas, page 241: Collection of John P. Axelrod,
Boston, Massachusetts

Blue, Period! oil on canvas, page 246: Collecion of the Artist

CHARLES BRAGG

JOURNEY EDITIONS
Boston ✳ Tokyo

Published in 1994 by
JOURNEY EDITIONS
153 Milk Street
Boston, Massachusetts, 02109

Asylum Earth is a work of satire. Outrageous acts and statements are
attributed to public personages, both living and dead, for purposes
of social commentary and are not to be taken as statements of fact.

LIBRARY OF CONGRESS CATALOGING-IN-PUBLICATION DATA

Bragg, Charles.
 Asylum earth / by Charles Bragg.
 p. cm.

 1. American wit and humor, Pictorial. I. Title.
 NC1429.B733A4 1994
 741.5'973--dc20 94-29431
 CIP

 ISBN 1-885203-07-1
 Text design by Cynthia Patterson
 Jacket design by Kathryn Sky-Peck

 First Edition
 1 3 5 7 9 10 8 6 4 2

 Printed in Canada by DW Friesen & Sons

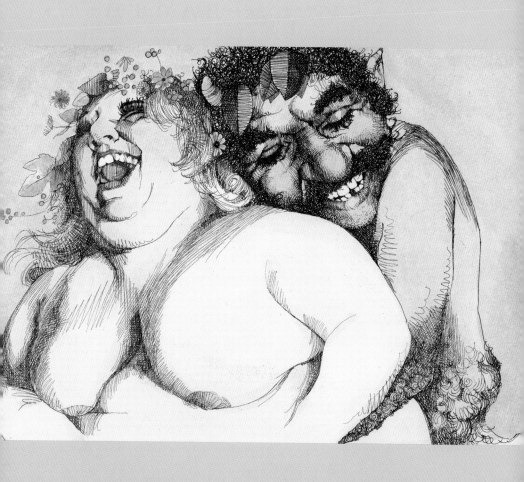

BEAUTY IS FLEETING,

BULLSHIT IS FOREVER

WELCOME TO
ASYLUM EARTH

❋

The first art sale I ever witnessed was in 1946. What amazed me, aside from the fact that one could actualy sell one's creative work, was that the sale was made by my teenage friend, Charles Bragg.

The transaction took place at the Burnside Billiard Academy, Bronx, New York. No money changed hands. In return for eight humorous drawings of various patrons frequenting the establishment, Charles received free pool time. The drawings were framed and hung right at the entrance. Every day we stopped to admire them as we went to shoot pool.

I relate the above not to tell you of our misspent youth, but to illustrate that Charles Bragg always had an eye for seeing the ridiculous in anything from the local poolroom, our high school, law, religion, the military, to sex and life in general.

Forty-eight years later, his satirical etchings and paintings hang in major museums and are sought-after and collected throughout the world. Few people realize that the scathing observations, the hilarious insights, and the irreverent humor coming out of Charles' brushes and etching tools also pours out of his writing. His words, put on paper, have almost never

been read by anyone other than his close friends. Through the years, Charles has sent me sketches, one-liners, poems, short stories and long stories. "You've got to get this stuff published!" I used to shout through the guffaws and tears of laughter as I read the various pieces.

At last it has happened.

I read somewhere that laughter adds years to one's life. If that is true, then Charles has lengthened my life considerably. Now, it's your turn. If you don't chuckle or laugh out loud at some of these stories, sketches, and one-liners, you have absolutely no sense of humor. Not to worry. I'm sure Charles is working on a story, etching, or painting to cover that very situation even as you read this.

He'll get around to you sooner or later.

—GENE LIGHT

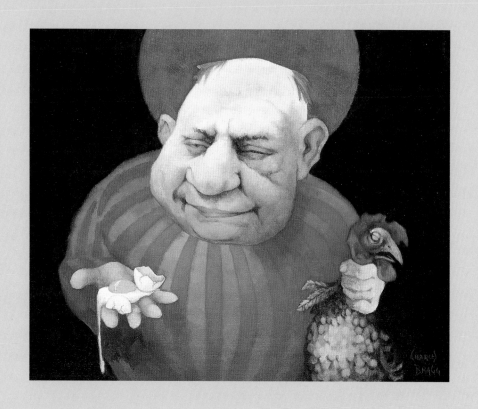

I THINK, THEREFORE I AM.

THE COVENANT

※

"**I** AM THAT I AM!**"** the Burning Bush said to Moses. "No, no. You are what you eat," said Moses. "I believe that's the way it goes."

"Fool!! Do you know who I am?"

"Yes. You just told me. You are who you are.""No! I am THAT I am. That! That!... I AM *THAT* I AM."

"You is what you is? That doesn't sound right to me."

"Oaf! Why would I make a covenant with such as thee?"

"Well, that's a two way street, you know. Why would I make a covenant with a bush... and a bush that can't even talk good English? Think about it."

"Have you ever had a plague of locusts, boils, droughts, floods, and fire descend on you? Think about THAT you moron!"

"Well, you don't have to get so high and mighty."

"I AM high and mighty, you dickhead! Don't you get it!?!"

"That's it, Goddam it. I'm not going to take this kind of verbal abuse any more."

"God damn it? Did you say *God* damn it?! You're not going to take this abuse, you say!! You just used my name in vain. You think *this* is abuse!? Schmuck. Check back with me in about 6,000 years and then talk to me about abuse.

※

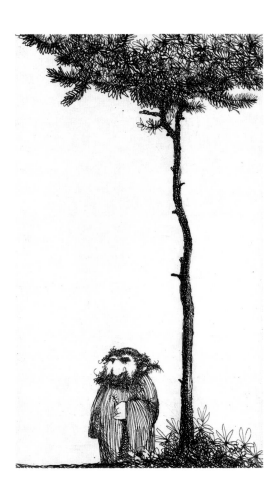

THE BIG HIM

*

Newsweek's February interview with God finally got down to brass tacks.

Newsweek: "Why do you, the Creator, permit so many seemingly meaningless tragedies to happen to good people?"

This question was asked while observing torrential rains from on high over Southern California in 1994.

God: "Mud slide!! Look at dat muuuhd shliiide, mon! Dat ole debbil mud. Ha, Ha, Hah. Oozing down dat ole debbil hill. Mon, right on tru dat Malibu Beach place. Ha Ha... Oh! Dere go de house...nice big one, tennis court and all. Right on down da hill and across da Pacific Coast Highway. Wow, almos' made it to da watah, mon. Anyone in dere? A whole family? Good! Ha, Ha, Hah!"

Newsweek: "You enjoyed that?"

God, switching from his Bob Marley to his Jackie Mason: "Oy yes!! I, The Supreme Me! The Ultimate Myself, *love* vhat's goin' on. I'm in charge of dah vay tings heppen on your earth. And If you don't like it, in Biblical terms... lump it, Buby!!"

Newsweek: "But why..."

God: "You want to know why I made the horendous downpour in California? Because of the mudslides.

Remember the fires that burned everything on the hillsides there in the first place? Without the drought, before the fire, nothing there would have been that flammable. So you see... no drought, no fires. Without the fires, no mudslides when it rains. Don't you see the grand pattern? And then, the 6.8 earthquake. There you have it. Nuff said!"

The *Newsweek* interview with God ended with that statement. What were its deeper meanings? And why was he changing dialects in the middle of his answers?

<center>※</center>

Watching half of California slide into the Pacific Ocean, a reasonably healthy mind would conclude that the things that happen here on earth might be the workings of a depraved, degenerate Type A personality. But "The Almighty Fiend" as Shelley or Keats or Coleridge once referred to him (they *all* burn in hell for this remark) is, I believe, merely bored. After several million years of observing what we have done with his gift of free will, we no longer amuse him. And who can blame him?

In the good-natured spirit of divine generosity, God has also mercifully given us the gifts of war, famine, pestilence, the Bible, rap music, the collapse of communism, Howard Stern, and Beavis and Butthead. Our cup runneth over. Yet we forsake him and cleave not unto his will. What is wrong with us? We had better start cleaving if we know what's good for us. And soon! The Big Him has let it be known that he is just and vengeful, especially vengeful.

It may be too late. I sense a definite change of attitude in His Mighty Sublimeness. He's pressing. Trying too hard to amuse himself. Like that calypso dialect thing he did in the *Newsweek* interview. *You* tell him it stunk. I'm not going to.

His attention span began to diminish around 30 million years ago. During that time, a great many fabulous creatures vanished from the earth. You see, for him, the whole "earth" thing started out as a harmless diversion, a sort of flea circus on a forlorn potato in a minor star system. He would check in on us from time to time just for laughs. We were no longer amusing him.

<center>✳</center>

Heaven must have seemed like a good idea at first. "Let them have everlasting song and succor," he decreed. In heaven there was no need for anyone to pray to God because by being there all their prayers to him had already been answered. He missed that. In heaven there was no need to praise his name. He missed that too. As a matter of fact, his name hardly ever came up. Another thing that irritated him was that everyone there was so happy, they didn't care how they looked. "Succor" was one thing, but gluttony was another thing altogether. He now had a heaven full of angelic overweight slobs. And then there were the hymns! The constant singing that had droned on since the beginning of time had begun to grate on his nerves. He loved Christmas carols as much as the next guy but not in July for Christ's sake! Bored, ignored, and rapidly losing interest in the everlasting happiness of the

righteous few allowed entry into the Big Forever, the Ultimate Rectifier decided to make some changes.

Occasionally, The Supreme Nitpicker would browse among human's trivialities on earth to see what was going on in their tiny little minds. He happened onto a copy of Dante's *Inferno* and found its description of the nine circles of hell absolutely hilarious. The sulphuric cauldrons of boiling slime filled with sinners in agonizing pain, the rending and screaming of the damned being burned and buried and tortured forever unto eternity—now that sounded like a real hoot. Why hadn't he thought of those things himself? He worked in mysterious ways but he still found it hard to believe that some Italian writer could come up with even worse stuff than he had when he created life on earth. He was impressed.

With the seed of Dante's comical new ideas planted in his consciousness, The Great Architect invented "sin." Then he created the Devil, fashioned as a sort of friendly competitor, and named him Satan.

To make things interesting, he gave Satan extraordinary powers. Though a clever adversary, he posed no real threat to God's supremacy. To God it was sort of like shadowboxing—watching an image in the mirror very closely although it can't do any real harm.

God gave Satan permission to duplicate Dante's vision of Hell perfectly. But as a sort of inside joke, he had him build it to 5/8 scale, just like Disneyland. This would make it even *more* fun he thought. God, The Ultimate Stupifier, then changed the rules for entry into heaven *or* hell. And to spice

up the game, he made all the rewards and punishments retroactive.

What had been a mortal sin or a heavenly virtue three or four thousand years ago was not the same for entry today, or in the future for that matter. For example, for a while, killing thy neighbor was OK, if they really deserved it and you did it in large enough numbers. If you don't believe me, ask the Canaanites. You could covet thy neighbor's wife if you were careful about it, and it was OK with her. You didn't have to do unto others as they would do unto you. You could ignore them completely if you wanted to. And "tradition" was no longer an excuse for stupidity. During eras of weak spiritual commitment, he even allowed his name to be used in vain. He figured that was better than having nobody talk about him at all.

Meanwhile, in the depths, busy on the fourth ring of "The Endless Numb," Satan was enjoying himself immensely. He had fashioned a most devilish torment. A sort of steeplechase of the hereafter. His idea was to have all the newly arrived souls who were clever enough, find their way through the "Maze of Remorse," climb the "Ladder of Abuse," and enter the "Dark Wood of the Unamused." Then over the "Arch of the Incoherent," and on to the "Pit of the Masturbators." The Pit was always writhing with blind and anguished young "weenie wompers," as he laughingly referred to them. Now though, because of God's new rules, they would not only have their sight restored, but would be given a magazine subscription to *Big Bad Mommas*, have the hair

removed from their palms, and sent on their way. All in his name. "Blessed be the name of the Lord." And then God, knowing that shit rolls downhill, put the "Valley of the Lawyers" directly below "Glutton Mountain." *Very* blessed be the name of the Lord.

Satan, in an inspired bit of creativity, outdid Maestro Dante himself when he came up with "The Cocktail Party That Never Ends." Sinners there were required to keep a perpetually frozen grin on their faces while listening to the same joke that they had been telling each other over and over and over again for centuries. You know, the twenty minute joke about the Pollack, the Catholic, the Protestant, the Jew, the Negro, the Chinaman, the nun and the midget who were stuck on a Boeing 747 with engine trouble over the Atlantic Ocean. I won't finish the joke now. You'll probably be hearing it someday yourself, and I don't want to spoil it for you.

❋

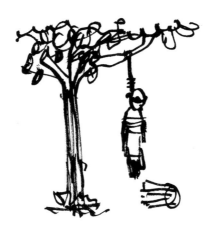

Only God can make a tree.

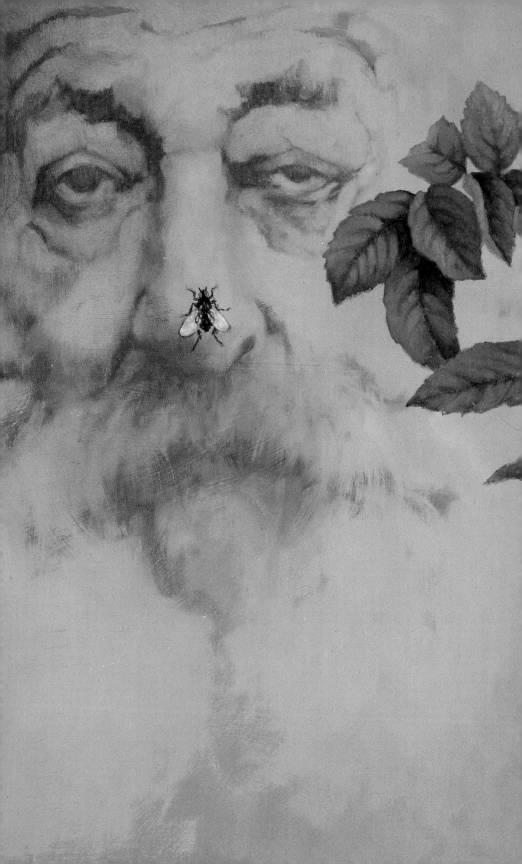

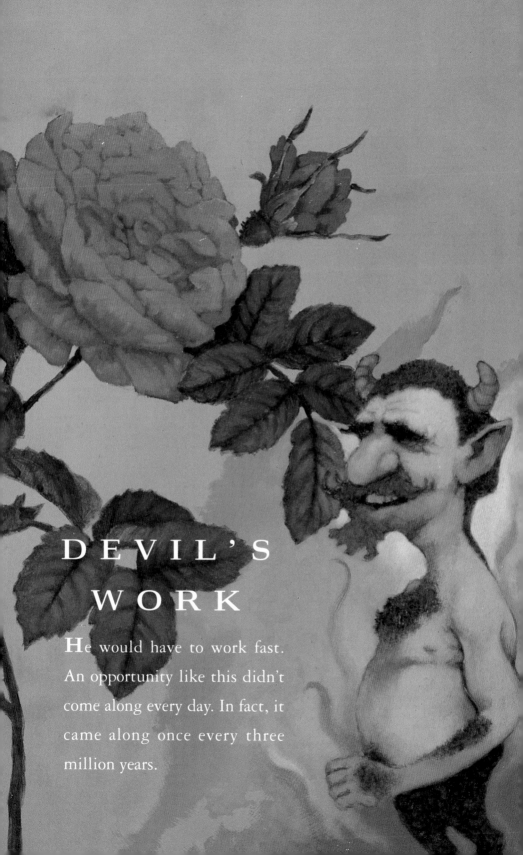

DEVIL'S WORK

He would have to work fast. An opportunity like this didn't come along every day. In fact, it came along once every three million years.

God had dozed off.

Satan had planned for this carefully. Selecting the lushest, most verdant, fertile garden of paradise, he gleefully turned it into a desolate, barren wasteland where no life flourished, no flower grew. He felt ten feet tall.

This was his most malevolent masterpiece. This huge, festering, open sore in the earth's crust, with red oozing gashes where clear rivers once flowed.

God was stirring now. In his after-nap haze, he had trouble remembering exactly when and how he had created something as magnificent as the Grand Canyon.

❋

The balance of nature?

I think we're talking leftovers.

FRANCIS

OF AZUSA

❋

The wild creatures of the world have never had a greater friend than Francis of Azusa.

His sweet nature and kind heart affected his ideas about the animals he loved so much, in a way that can only be viewed as poetic. Nature's indifferent ways were not his ways.

For example, Francis was sure that possums play dead for the same reason he prayed—so they would be ready when the real thing came along. He hoped that someday dolphins would let us in on what they found so amusing. He believed that almost all warthogs led celibate lives, and that the few who din't, imagined they were doing it with gazelles.

He felt that whales are bored stiff, that's why they beach themselves, that bumblebees and hummingbirds must be exhausted, woodpeckers get terrible headaches, and penguins are freezing their buns off. He was certain that bats used sonar because they can't stand the way they look either. He wanted to find out who ate dead vultures.

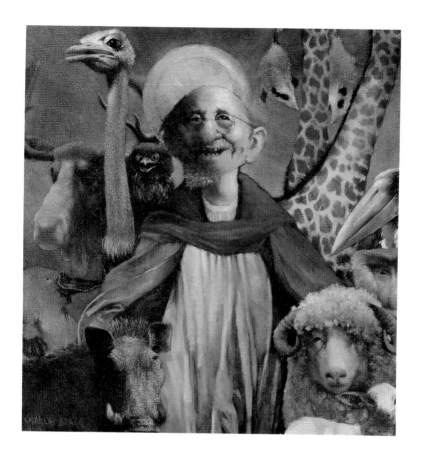

Those were just some of the things Francis of Azusa was determined to do something about.

Even sympathetic animal rights groups thought his methods extreme.

He ran with the morons at Pamplona and tried to reason with them. He tried to get cheetahs to develop a taste for acorns and berries and leave the wildebeests alone, but they chased his ass all over the Serengeti Plain.

He got a lamb to lie down with a lion, but when he got

back from a lunch break he was surprised to find that the lamb had left.

He abandoned his crusade to turn nature's predators into vegetarians when he realized that some plants have central nervous systems.

Yet no sparrow fell that did not cause his heart to ache. The gentle and saintly Francis could not even bring himself to swat a mosquito.

He died of malaria.

The innocent wild creatures of the meadow, vale, forest, and plain did not mourn, nor really notice his passing. And in the spruce woods, deep in fern and thistle where he peacefully rests today, the rain falls and the wind blows just as it always has.

✳

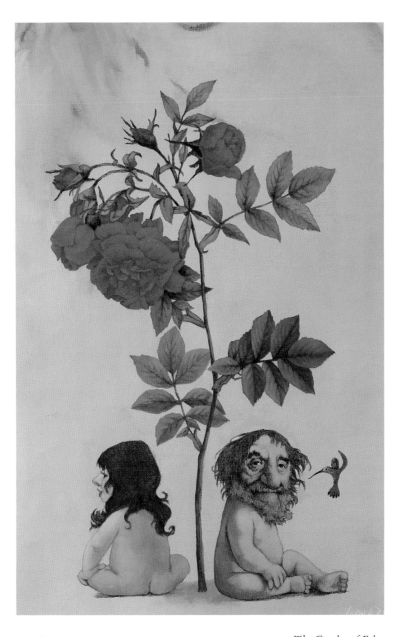

The Garden of Eden

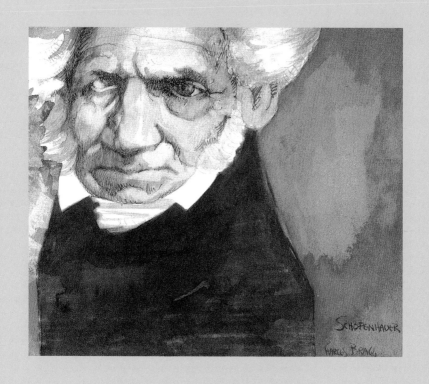

I THINK ALOT, THEREFORE I AM A LOT.

THE MORE
THINGS CHANGE

❈

General Robert E. Lee, the military commander of the Confederate forces, graciously accepted the complete surrender of Ulysses S. Grant and the Union Army at Appomattox. The bloody American Civil War was over. The South had won decisively.

President Jefferson Davis moved immediately into the White House.

Abraham Lincoln received a full pardon and spent the rest of his days peacefully caring for his lunatic wife, Mary Todd Lincoln.

The South had won the war, and, in effect, *all* the states now had the right to secede from the union and become independent nations, with their own flags, their own armies, and their own laws.

The Balkanization of the United States began not long after. The fragmentation of the states dwarfed the behavior of the very Balkans themselves.

There had always been the states of North Carolina and

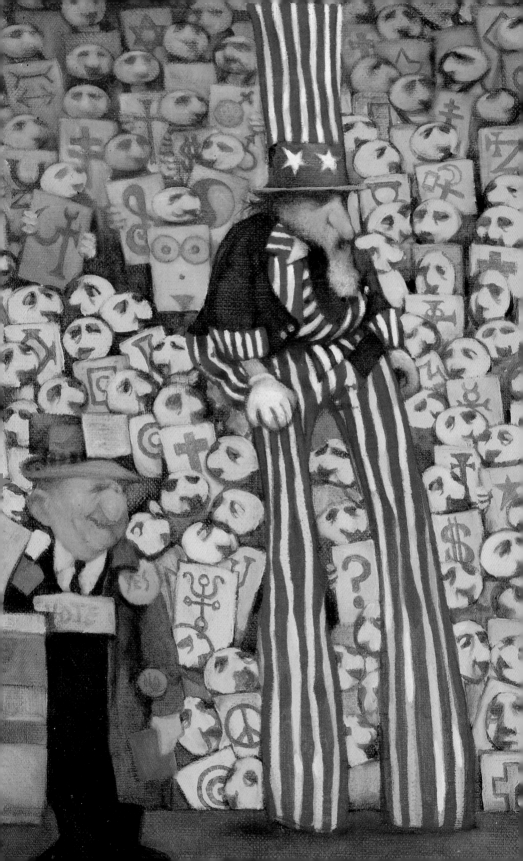

South Carolina, a Virginia and a West Virginia. Now they were countries. Then came a North New Jersey and a South New Jersey, a West Rhode Island as well as the regular Rhode Island. The Grand Canyon state became Lower Arizona and Upper Arizona. Greater Delaware and, would you believe, the oxymoronic Lesser Delaware were created. So was the independent Island Empire of Staten. There was a Main Maine and the Other Maine. All sovereign nations.

The corn growers of Kansas joined with the string bean farmers of Oklahoma to form the new nation of Succotash.

Portuguese was declared the official language of Kentucky.

Not long after declaring their independence, Arkansas and Mississippi went to war when the IQ test scores of the elected leaders of both of those states were released by Connecticut's ruling military junta headed by Generalissimo G. Armstrong Custer.

About the same time, a most tragic confrontation occurred in Outer Pennsylvania. A buggy full of Amish thugs raided a Quaker quilting bee and stole several shawls. The conflict that followed will forever be known in military annals as the Plowshare War.

The bloodiest encounters were fought between the Irish Communist Militia of Massachussetts and the Falangistas of California. It came to an end when they joined forces to oppose barbarian invaders from the north — Viking dairy farmers from Wisconsin and Minnesota.

A seemingly minor border incident awoke the "sleeping

tiger" of the retired elderly of Florida. They bravely repulsed the incursions of the beer guzzling Peckerwoods of Alabama.

As often happens in monumental upheavals, the lives of individuals as well as nations take dramatic turns.

For example, Al Jolson, while singing "Mammy" in a minstrel show in Biloxi, was arrested under the Fugitive Slave Act by John Wilkes Booth the 3rd, and returned to his rightful owner, a rabbi in the Bronx.

Incidentally, John Wilkes Booth the 3rd was shot shortly after that by Dred Scott the 4th.

In more recent times, the Mormon Bigamists of Utah attacked the Godless Opportunists of Nevada for complete control of casino gambling in that neck of the woods.

In 1972, after a geological survey made sure no oil was to be found there, the United Nations of North America voted the newly freed African slaves their own homeland. The Cherokee Indian Reservation on which it was to be located would forever be known as New Liberia. Details of the response of the ungrateful Cherokee people to this act of generosity are too depressing to dwell on at this particular time.

It's hard to say exactly what caused all the disparate states to reunite. But they did. Was it the Red Menace? The Yellow Peril? The Riders of the Purple Sage? Who's to say? Most likely it was the fear of a massive seaborne invasion of the North American continent by the Rice Farmers of North Vietnam.

The miraculous reunification of the states in response to imminent danger inspired a radiant period of reconciliation,

unity, and brotherhood. It lasted for almost three weeks.

Some things didn't change—the Purple Mountain's Majesty, the Amber Waves of Grain. However, the Fruited Plain was now the name of the only completely gay state in the Union.

Amazingly, I believe that if all of the above historic events had actually happened, by now our national deficit would have reached monstrous proportions—our education system would be a disgrace; our bridges and infrastructure would be in shambles; drugs, crime, racism, and homelessness would be rampant in our streets; aimless youths would become mindless predators; and—most important of all—I would *still* be two months behind on my car payments.

"How can I hurt thee
Let me count the ways"

THE ONE-LEGGED

BEEKEEPER

❋

Old Silas, the one-legged beekeeper, was not even aware that the Crusades were over. He did not have time to keep up with events so far away. Tending his hives and raising a daughter was all a feeble one-eyed cripple could manage.

One morning, when he and Amanda were working among the hives beside Mill Pond, they were suddenly confronted by a rogue knight in black armor on a huge charger.

"Away, old wreckage! It is the maid that I want and it is

the maid I shall have!!" he roared, as he dismounted and strode towards Amanda.

His massive arms lifted her as they might a child. The beautiful young peasant girl's struggles were as nothing to Sir Mordred. Her scratching and beating against his armor only heightened his evil passion.

"No!" the helpless old Silas wailed, picking up a stick. "If only I were strong and this hive were that knave's head, I would teach him a lesson."

Thwack!

"But no, I am old and weak, and take my anger out on these hives."

Thwack! Thwack! Thwack!

Hive after hive he smashed and pummelled.

Silas paid no mind to the swarms of bees he had lashed into a fury. Seeking revenge, the bees now fairly covered the netting that he, like all beekeepers, wore over hisbroad-brimmed hat. So thick were the swarms of enraged bees, that when he stopped for a moment to catch his breath, he could barely make out the vague outline of a frenzied figure in black armor clanking at full speed towards the little stone bridge in the distance. When the knight reached the bridge, arms flailing left and right, surrounded by a roiling storm of infuriated bees, he threw himself over the wall and into the dark water.

Sir Mordred sank to the bottom of Mill Pond like a stone. The two thousand bees trapped inside his armor drowned about two minutes before he did.

During the Crusades, the chastity belt made it impossible for wives to fake orgasms while their husbands were recapturing the Holy Land.

THE NAIL

For the want of a nail, a shoe was lost.

For the want of a shoe, a horse was lost.

For the want of a horse, a knight was lost.

For the want of a knight, the war was lost.

For the want of a brain, we listen to this drivel.

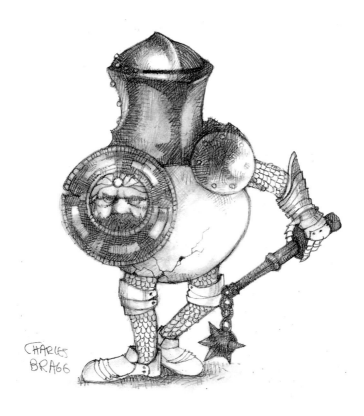

HISTORY

IS BUNK

❋

A rnold Toynbee surely must have looked the other way when writing his masterful *A Study of History.*

His research, as we all now know, found that in 1353 Marco Polo brought spaghetti to Italy from the Orient. He also brought back a wondrous new discovery from China— gunpowder!

Why Toynbee would suppress the fact that, for the first seven years after Marco Polo's return, the Italians thought they were supposed to sprinkle the gunpowder on their spaghetti is beyond me.

❋

For me, the "Age of Bronze" was between 15 and 19.

THE

HONOR FARM

❄

Warden Coots always made a point of greeting new prisoner arrivals at Allenwood so there would be no misunderstandings about how he ran things, and to explain, in no uncertain terms, what was expected of them.

This morning's new arrival was different. It was the crew from the television show, *60 Minutes.* Cameramen, soundmen, lighting technicians, makeup artists, and correspondent Morley Safer himself.

Safer graciously introduced himself to Warden Coots and added, "Call me Morley, please, Warden Coots."

"Call me Bubba, Mr. Morley, please," said Warden Coots, "I want you to know it's an honor to welcome you to Allenwood Federal Prison. I watch you all the time. You're on Sunday, right? You know, Geraldo Rivera wanted to do his TV show here too. But he was mainly interested in transvestites, animal fuckers, and cross-dresssing stockbrokers. I turned him down even though we do have quite a few of those types here."

Safer was amused but not surprised, "Warden Bubba, what we'd like to do on this segment of *60 Minutes* is sort of

a 'Lifestyles of the Rich and Famous in Prison' piece. Many people have the perception that Wall Street crooks go to 'country club' prisons. You know, the Club Fed thing. So we'd like to find out just how many insider traders, stockbrokers, and savings and loan people you have here at Allenwood Federal Prison Camp."

"Well, we got our share, there's no doubt about that, more than our share if the truth be known, Mr. Morley. We got our doctors and lawyers too, plenty of 'em. We got senators, we got murderers, we got movie critics, and everything in between."

"Warden Bubba, Allenwood Prison is 4,000 manicured acres—no fences, no bars, no guard towers. You have a billiard room, a gym, a racquetball court, tennis courts. It's West Virginia and the Appalachians, not the Catskills. Can you understand that the public perception is that you run Allenwood more like a resort than a prison? Would that be a reasonable interpretation?"

"Well now, let me ask *you,* Mr. Morley, if you had to keep 1,200 prisoners busy twenty-four hours a day, don't you think your acres would be manicured? That's the whole point. Keeping everyone busy. Everybody works here. Not many people know it, but we make all the jockey shorts for the U.S. Army. All of them. Every soldier in Desert Storm was wearing a pair of our shorts, even General Schwartzkopf. It made us real proud that when our fighting men were bravely defending the New World Order, they had their prunes securely cradled in a product we make right here at Allenwood.

"We also make fine walnut executive desks for the government in our furniture factory. They're in every U.S. embassy in the world, and there's a waiting list for them. Our prison workforce earns eleven cents an hour to start, forty hours a week; thirty eight cents an hour after three years; last year we had $4.6 million in sales. If our people meet their quotas, their stays here may not be that unpleasant. If not, they don't get to use any of those little goodies you mentioned. Plus nobody wants to get transferred to Rahway or Attica and end up being someone's 'June Bride' and I do mean 'end up,' if you know what I mean."

"I think we get your meaning, Warden Bubba."

"Here's a story for you," said Warden Coots. "We got 'Pop' Scales transferred here from Leavenworth a while back. He was eighty-six years old, and had just six months left on a fifty year sentence, so they sent him here before he would be turned loose. He had been a model prisoner and seemed harmless enough, and after a half century of hard time in the slammer, you couldn't help but wonder if he could cope with life on the outside. We had planned to use that last six months to train him for a career as a busboy so he could earn an honest living in a competitive economy. But you know, here at Allenwood we don't have fences and that old fuck escaped. Can you believe it? Eighty-six years old and he walks right off the grounds and goes out and robs a 7-Eleven store within twenty-four hours. They say he had a touch of Alzheimer's and that that's all he could remember how to do, so he went out and did it. Died in a shoot-out he did.

Hard Copy did a piece on it on TV. Real poignant, but they really didn't know how mean that old prick was. Getting poked in the boomer since 1936 can do that to a man, I guess."

Safer thought for a moment, probably about how many bleeps would be in the final telecast, "Hmm... yeah... maybe so... yes, kind of ironic... Well now, Warden Coots, what we'd like to do today is photograph the grounds and facilities here with your commentary as we go. Sort of a voice-over. Do you have any problem with that?"

"Fuck no, I'm real proud of Allenwood. A couple of our inmates have been on the cover of *Forbes* magazine for chrissake, four of them have books on the *New York Times* bestseller list, and a couple of them have had TV miniseries made about them already.

"I'm sure you make pretty good dough, Mr. Morley, but how would you like to match financial statements with some of these crooked buzzards? I don't think so. We got a guy here who robbed an auto workers' pension fund in Michigan. Just wiped it out. He was fined $400,000,000. He paid it out of petty cash and has plenty left over for when he gets out, which will be in ninety days or so. Of course he's going to have a lot of elderly, penniless, vengeful auto workers after his ass, but I don't think that will bother him too much on the French Riviera."

Coots adjusted his shorts. "Over there is our baseball diamond and miniature golf course. See that guy cutting the grass? That's ex-Supreme Court Justice Orlin Spencer. He

keeps the field real nice. Used to umpire our games too but we had to stop that—too many bad judgment calls.

"We got a goddam Hall of Fame baseball player in here right now. But you know something? He can't hit a slow pitch softball to save his ass. Swings like a goddam girl. Now there you got an angle on a story—'Home Run' Baker can't hit a beach ball thrown by a Wall Street faggot."

With the camera crew taping their every move, Safer and Coots walked past the vegetable garden where several dangerous looking men were spreading manure on the tomatoes. They entered the back door to the the mess hall kitchen.

"Tell me about the food here in prison, Warden Coots."

"Well, I wouldn't claim it was Denny's or Sizzler's or anything fancy like that. You see that pansy at the grill over there? He's a fruit, gayer than ice cream, but he can really cook! He was the pastry chef at the White House during the Nixon administration. He's been here for eleven years. For what, I've forgotten. But I'll tell you this, when he gets out he's going to be bigger than Wolfgang Puck. He's working on a book, *The Minimum Security Prison Diet Book of Recipes.* I eat here three times a week, and I've lost forty pounds in the last eleven years. So it works. We got more than 1,200 prisoners here and you can't please 'em all. We got people here who are disappointed that he makes 'shit on a shingle' with meat. Geraldo was interested in that. Anyway, he makes 'Nachos Haldemann' and 'Enchiladas Erlichman' from the old state dinner parties, and they are out of this world. Really

stick to your ribs. As a matter of fact, they stick to your ribs for three or four days.

"We got a kosher kitchen here too, 'strictly' as those people put it. Vegetarian food too. See that guy out there pulling up bean sprouts and eating them? Wouldn't harm a cow, but I think he killed his grandmother last year for changing channels on his TV... just kidding.

"There *is* one line we don't cross here—no booze. Cocktail hour here means a twist of lemon in your Diet Pepsi, or neutral spirits on the rocks, no salt, please."

"What are neutral spirits?"

"Water... and that's tough for some, I guess. Even if you can't drink, you miss just ordering it. I wouldn't know, I've never had to do without it.

"You know we have a lot of brilliant assholes in here, all convicted felons. They're in prison! And yet you never hear about any trouble here at Allenwood, do you? I could dog and grind 'em... break 'em, you know. But I don't. The secret of keeping peace and order in this place is psychology.

"What do you mean by 'psychology'?

Like, I put a golf pro in the same cell with a coal miner, a faggot in with a bounty hunter... team a preacher up with a pornographer, and let 'em learn from each other. As I say, I use psychology!"

And does it work?"

"I know it does. I'd like to put Jeffrey Dahmer in the same cell with Michael Milken. Then secretly tape what they

have to say to each other. And have it transcribed. Who wouldn't want to read that?"

"Wouldn't that violate their basic constitutional right to privacy?"

"Oh my!! Let's see, let me check my copy of the Constitution... hmm... Bill of Rights...hmm, First Amendment... uh huh, Fifth Amendment... Eighth Amendment... OK! Good, that's it!! It's constitutional! The Founding Fathers would definitely want to hear this. They'd just love it. There's no doubt the Founding Fathers would want to hear what Benedict Arnold said to Aaron Burr when he changed sides after the Battle of Bunker Hill. It's definitely constitutional!"

It occurred to Morley Safer that perhaps the prison system was not the only story here. Warden Coots was! As it so often had in his travels, the Demon of the Unexpected had struck again.

<center>❋</center>

After a short break, Safer resumed the interview just to the west of the putting green.

"Warden Bubba, with so many millionaires and billionaires as well as very powerful and influential people here, it's hard to believe that they don't get special treatment. What should the public know about that?"

"Mr. Morley, let me just tell you a story. I was eating in the convicts' cafeteria one day, you know, to show that the food wasn't poisonous. I started to gag. I got numb.

<center>39</center>

Everything seemed to be moving in slow motion. I blacked out. I was choking to death in front of 600 convicts and I was unable to make a sound to let anyone know. Everything sounded like I was in an echo chamber. I was dying, no doubt about that. They tell me I was turning kind of blue when Big Boy Dorkin noticed I was in trouble. Well Dorkin is two-hundred-and-sixty pounds of dangerous and hostile muscles, and he put a Heimlich maneuver on me that hurled a piece of meatloaf across the room that knocked a guard unconscious. He also broke three of my ribs—but fuck, I'm alive! And I owe my life to that big slob. Big Boy is in here for stealing food stamps. Hasn't got a dime to his name, but I make sure he's treated just as good as any millionaire in this joint. On the other hand, Ivan Boesky, who was sitting across the table from me, just sat there like it was a fucking corporate takeover and watched me change colors. Didn't lift a fucking finger to help me. I made sure his last few months here were real memorable, I can assure you. So you see, I treat everyone the same—rich or poor, especially if they have saved my life."

"Just how do you make things especially memorable for someone here, Warden Coots?"

"Well, first off, no TV! Ever see the look on the face of a Rhodes scholar-millionaire-embezzler when you tell him his TV privileges are revoked? They lay in their cells and whimper like sick dogs. I'm talking about guys with 132 IQs. They miss three episodes of *Days of Our Lives,* and you never have any more trouble with them ever again.

"A while back, I had an attitude problem with 'The Honorable' Julius K. Felder—remember him? The mayor of Youngstown, Ohio. Ran a sports book from his office in City Hall. I had him pulling weeds in the yard all day on Super Bowl Sunday XXVI. Wouldn't let him watch the game. *Monday Night Football* was sort of a religious experience for him, so he claimed that not being allowed to watch the Super Bowl constituted 'cruel and unusual punishment.' He claimed that by missing the game, he had suffered not only mental and physical anguish, but a permanent psychological scar. Have you ever heard such bullshit? It's on appeal now, and probably will go all the way to the Supreme Court. I don't think I'll have any more problems with him though. I put him in the same cell with G. Gordon Liddy for six months.

"Also, little lessons in humility work real good too. See that guy busing the tables over there? Well, he was a big spender, a real party animal. You know, flew to Paris on the fucking Concorde, went to the Cannes Film Festival, winters in Monaco. You know, all that fancy bullshit. Threw himself a birthday party at the Waldorf Astoria for 400 of his best friends. Cost him $80,000 just for the flowers. Well, you know where that dickhead got his money? From the 'Magic Wish Foundation.' That outfit that gives kids with terminal illnesses their last wish, you know, make it come true. He was on the cover of *People* magazine. He just got beat out by Mother Theresa as Humanitarian of the Year in 1987. Raised millions. Guess how much he spent on the kids? Not one fucking dime! And then he prances in here on his first day

like a goddam peacock—Gucci loafers, Rolex watch, Armani suit, and he looks around as if he's displeased with the accommodations. Well, within 10 minutes he was on his hands and knees scrubbing floors in the crapper. And he'll be there until he gives a pint of blood to the Red Cross every two weeks for the next year. After that he'll sort X-rays at the Children's Free Clinic in town until there's a cure for cancer."

"Make the punishment fit the crime, is that it, Warden?" Safer said. "Sounds like a story Andy Rooney could really sink his teeth into. But let's move on. Many people feel that most of the inmates are in here for the least of their crimes, and that smart lawyers always plea bargain them out of the real jams."

Coots was amused. "Well, let me just say that a good portion of our prison population is made up of 'smart' lawyers."

Morley Safer smiled, "That doesn't surprise me one bit. Clear up something else for me, Warden—sex! There have been rumors that during visiting hours there's a lot of it going on here at Allenwood behind your back. Is there any truth to that?"

"Well, let me ask you how you would handle it. I got 1,200 testosterone-burdened felons in here, and some of them are so horny they glow in the dark. So some of those rumors may be true. I let a few of them have a little Sunday picnic in the bushes now and then. If they've earned it. We got 4,000 acres here, and you can't watch everyone all the time. Besides, a little pussy from time to time never hurt anyone. It's better than having them humping each other

during the week isn't it? Also, it's a perk that they don't want to lose, so it helps to make everyone easier to deal with the rest of the time. I think it might be an idea whose time has come, don't you?"

"I think you'd have a lot of resistance from conservatives and Fundamentalist Christians on that one, Warden Coots."

"Oh really! Well, we have plenty of them in here too, and I can tell you they look forward to their picnics just as much as everyone else. They disappear into the woods and come out with just as many grass stains on their chins as anybody else—maybe more. Let's face it, Mr. Safer, you can whip the old willow for just so long, and then you want a little human contact. Right?"

"Well..." Safer paused. "Tell me more about your thoughts on this."

"Hey, don't get me wrong. I'm not one of those bleeding hearts. You know, that 'human potential, anyone can be rehabilitated' bullshit. A rapist shouldn't get for free what he broke the law to get in the first place. No. His fucking days are definitely over.

"When someone goes to prison, all they can think of is how to get sex. I think that's why people get sent to prison. So they'll never bump their uglies again, you know what I mean? A guy robs a liquor store, kills a couple of people. The pollsters come out... 'Should he get the death penalty?' Well, I'm undecided about that but I *do* know I don't want him to ever get laid again!

"Look, I'd pull the switch on a lot of these so-called

members of the human race and sleep like a baby that very night. But listen, the stakes here at Allenwood are peace and tranquility versus trouble and mayhem. That's the way I run things here. Produce! Earn! Reward! Produce! Earn! Reward! Shit, man!! It's fucking capitalism! It's Darwin and the 'survival of the least humane.' What's that you say pal!? You're going to fall short!? You didn't prosper!? String his ass up!!"

It was getting late now, and Morley Safer had to get to the studio. He had a long day of heavy editing ahead of him.

<center>✻</center>

After the segment on 60 *Minutes* was aired, Warden Coots became something of a national celebrity, which put him on equal footing with many of the inmates in Allenwood Prison. The media's general consensus on Coots' success at Allenwood was that he was a man who not only suffered fools gladly, but who got a genuine kick out of them. And there were more than enough fools at Allenwood to keep him amused.

For example, take the Garbanzo Brothers, Bruno and Vito. Identical twins, they were not unlike the Corsican Brothers—when one brother got hurt, he made sure the other brother got hurt; when something good happened to one of them, he made sure the other one found out about it. They were in Salt Lake City in the FBI's witness protection program. Four Brooklyn Mafia Dons were doing hard time because of their testimony. Common sense would presumably

assure that they would keep a low profile. No one had ever accused the Garbanzos of having common sense.

Now anyone who has been there knows, Salt Lake City is probably the worst town in America to open a topless bar in. A town so uptight you have to belong to a private club to order ketchup, and laughing out loud is a felony. To call the club "The Tush and Bush" and distribute graphic handbills at town hall meetings was something only the Garbanzo twins could have come up with.

They began to dabble in soft-core pornography on weekends and were busted with their movie, *Mormon Hormones,* only half completed.

The cops that made the arrest and the prosecutor who tried the case didn't know identical twins were involved so only one Garbanzo brother was tried and convicted.

The brothers very honorably alternated doing time at Allenwood. Bruno would serve six weeks and then on visiting day, when the opportunity presented itself, he would switch places with Vito. Warden Coots was probably aware of all this, but as long as one or the other brother was doing the time why make a big deal out of it?

※

Coots took a personal interest in greeting his newest guest.

There he was, Charles Keating, America's number one champion for a return to the Judeo-Christian ethic and Richard Nixon's most outspoken anti-pornographer, waiting

in line for his Allenwood prison uniform. Charles Keating, President and CEO of Lincoln Savings and Loan. Tall, straight and stiff, white haired and born again grim, his wire rimmed glasses wedged on a long pale face. In his silver suit, steel gray tie, and aluminum ass he could have been the Tin Woodsman's uncle. The great Rembrandt could have rendered his portrait with nothing more than a No. 2 graphite pencil and gotten a perfect lifelike likeness. However, his appearance was a veritable rainbow compared to his personality, which was reported missing long before the 250 million dollars he had embezzled from trusting senile retirees—one of which was Warden Coots' mother.

The wind chill factor in Keating's eyes was numbing. To picture him laughing or smiling would require the imagination of Salvador Dali.

In short, Keating was the very image of what H.L. Mencken termed "that most dangerous of nature's predators—the Christian businessman."

He had been an elder at St. Luke's Lutheran Church in Scottsdale, Arizona. And he had not missed teaching his Sunday School Bible class in twenty years. Some believe that young children are morally strengthened when confronted with the torment of going to hell forever. A sample of what it might be like every Sunday morning could very well turn those young innocents into good God-fearing Christians.

Warden Coots decided to bunk Keating with Icey Kool Jazzy Zee, who had won last year's *Soul Train* award for being the most irritating and incoherent rap artist of

the year. He not only won the award but actually talked that way all the time.

Coots was not only a superb prison administrator, but a world class voyeur and eavesdropper. He loved his Thursdays. That was when he relaxed at home, had a few belts of Jack Daniels, and reviewed his secret tapes to find out how his ingenious combinations of prisoners were working out. He had spent some time in London in the sixties and remembered that, after a week, he started talking with an English accent. Linguistically speaking, he wondered how the pairing of Icey Kool Jazzy Zee and Charles Keating would work out.

<center>✳</center>

Oscar Nerlman woke up in a cold sweat.

This wasn't the first time he had survived a death sentence in his dreams. His recurring nightmares always ended with him going to the chair or scaffold—and always for saying the wrong thing at the wrong time to the wrong person. It was his gift. A gift that certainly didn't enhance his career as a criminal defense lawyer. As a matter of fact, it had turned many an otherwise brilliant defense into disaster. When he delivered his summations to the jury he invariably misspoke.

"Ladies and gentlemen of the jury, it's better that a hundred guilty child molesting murderers go free than that one innocent man be imprisoned unjustly for even one day," he proclaimed and pointed to his client, the defendant Matt

"Psycho" Terbloch, accused serial killer, rapist, and pederast.

Somehow the jury didn't feel Terbloch should get the benefit of *that* doubt, and sentenced him to 450 years in Attica—after which he was to be executed. It took the jury four minutes to reach their verdict.

That was long ago. Now Oscar Nerlman was in Allenwood himself. He had made a mistake by deciding to represent himself at his own trial for mail fraud.

"No one has ever been hurt by an envelope!" he shouted with all the sincerity he could subpoena to his lips, "...except for maybe by a paper cut." He then rested his case.

He was sentenced to two years for an offense that usually got six months, and here he was in Allenwood in a dorm with three of his former clients.

At least "Psycho" Terbloch wasn't there. In his first week in Attica he had killed three convicts and crippled a fourth in a disagreement over a pack of Marlboro 100 Lights. They added another 200 years to his sentence. Even Hannibal Lecter was scared of him.

Terbloch would not set foot in a minimum security prison like Allenwood in the foreseeable future.

❈

The 60 *Minutes* piece made Warden Coots a media darling. *Architectural Digest* featured a cover spread on Allenwood. Annie Leibowitz did a very creative photo essay on Warden Coots for *Vanity Fair*, a magazine that reached a

lot of people who would probably end up in Allenwood sooner or later.

Coots' full hour on the *Larry King Show* deftly fielding telephone questions from Indonesia to Nashville in his colorful way produced some memorable exchanges.

"It's a given, Warden Coots, that a lot of the people in prison claim they're innocent. Do they present any special problem? How do you handle them?" King asked.

"Well Larry, you know, they all have a story. Some of them are real fucking doozies. Take Dr. E. Plumline Koozman, the disgraced Beverly Hills gynecologist. Big celebrity clientele. Lots of big show business names. It seems that one day he had Kim Basinger in the stirrups for an examination. He claims he suffered from narcolepsy, and that while examining her, he fell sound asleep and pitched forward, burying his head in her crotch. He said it was a good thing she screamed and woke him up or he might have suffocated. He was caught with his head in the old Bermuda Triangle, so to speak. When she went public with the charges of malpractice, about a hundred other women came forward with similar stories.

"It turns out he also considered all his examinations photo opportunities. *The National Enquirer* bid $5,000,000 for the negatives, but they were confiscated by the court and somehow got lost in the judge's chambers. The judge was H. Thornton Rule. He's in Allenwood now for jury tampering. I'm going to have a long talk with him about those pictures. I'm sort of an amateur photographer myself, and I'd love to see them, wouldn't you?"

"Well we'd certainly like to have him on our show... and his pictures too of course. Ha, ha." King babbled profoundly. "Let's take some calls. Knoxville, Tennessee you're on the air with Warden Coots."

"Do you have any philosophers like Howard Stern in Allenwood?"

"Awright, excuse me, Warden Coots." Larry King, apologizing, "There are a lot of nuts out there. Let's take another caller..."

"Well now, wait a minute. I don't mind answering that one. We got our philosophical types in Allenwood too. You know, deep thinkers. Take Allie Sacks. Fancies himself a real maverick. Always babbling about freedom of speech... I never heard him say anything that would be banned anywhere. He's the guy who came up with the 'frozen peanut butter ball.' "

"The frozen peanut butter ball?"

"Yeah. You see, in 1966, at the height of the Vietnam War, he got called up in the draft. He didn't want to go, you know, one of those peace freaks. Anyway, he put a ball of peanut butter in the freezer overnight. Swallowed it whole the morning he took his physical. It showed up on his X-rays as a spot on his lung and they wouldn't take him. Can you imagine the warped brain that could come up with something like that?

"As I said before, he was the philosophic type, and one day he got real poetic and tried 'walking a mile in another man's shoes.' Evidently he enjoyed it so much he decided to drive to California in another man's car. He was arrested in

50

Tucson for grand theft auto. You ought to have him on your show when he gets out. Yeah, a real intellectual he is. A royal pain in the ass... hasn't got the sense to hit the ground with his fucking hat."

✻

Not all the inmates in Allenwood were fancy people. Some were just plain folks. None were plainer than Hack Waslonski.

When Hack Waslonski left Swamp Knob, Mingo County, West Virginia, for the Allenwood Prison Farm, unemployment there was 38% and climbing. It wasn't long before the Waslonskis found themselves on welfare. Every week the line of the unemployed lengthened for the usual allotment of surplus cheese, sacks of flour, powdered milk, and tomatoes from the Department of Agriculture.

With all that stuff, Hack's wife, Bella, figured out that all they needed to start their own pizza business was an onion and some cardboard boxes. They did just that.

Bella cooked the pizzas in her tiny kitchen and the Waslonski twins, Hack Jr. and Tom, delivered them. Little Luke hand lettered the boxes: *Waslonskis Authentic Eyetalian Pizza*. With that ethnic ring to it in their neighborhood, for a while they prospered.

It wasn't long before the Department of Health closed them down. They accused Hack of using contaminated ingredients in his pizzas—cheese and flour that contained rodent hairs, insect parts, and some things they called 'fecal material' and 'life-threatening bacteria.' The Pure Food and

Drug Administration also booked him on a charge of 'public endangerment.'

Hack had read that all men lead lives of quiet desperation, but this was ridiculous.

"Shit! I got all that stuff from the government in the first place. I fed it to my family. I ate it myself! Oh sure, that's OK. But I sell it to someone else to eat, and all of a sudden it's poison."

Hack was found guilty of all the charges and sentenced to serve additional time for "contempt of country." That is to say, questioning our nation's motives in giving away rotten foodstuffs to the poor people of Appalachia.

※

Sunday! Visiting day! Picnic time! To really understand Allenwood one had to be there on visiting day.

If the executive desk and jockey short production quotas were met, Warden Coots ran a loose ship on these days and the general mood at Allenwood always ran very high. The guards kept a low profile and gave the inmates a wide berth, especially around the picnic tables. It was May and a lovely spring day for a picnic.

After picnicking and visiting and talking with wives and girlfriends, it wasn't unusual to see couples walking hand in hand towards "The Grove."

The Garbanzo Brothers had picked out a table near the volleyball courts and were surrounded by fourteen of their laughing happy children. Their wives stirred a huge boiling

cauldron of spaghetti that could have fed Mussolini's army. Fried peppers, lasagna, pizza and Pepsi cans filled with chianti made these days memorable for the mouth-breathing Garbanzo family.

Charles Keating and his wife had spread a blanket on a knoll under a shade tree. While he ate an American cheese on white bread, she read passages from the Bible aloud to him. After a while, he put down his sandwich, looked into her eyes, took her hand in his and said, "Martha, read me the passage where God says he wants us to go forth and procreate."

After Martha's reading, with heads bowed and without another word, they headed towards "The Grove."

"The Grove" made Allenwood different from other Federal prisons. A beautiful verdant stand of trees, soft mossy grass, and at some distance from the main complex of buildings. Most importantly, it was surrounded by a thick curtain of oleander bushes. The way he allowed it to be used made Warden Coots the most controversial man in the Federal penal system.

Coots had no formal education but had tried to read all books by the "Great Thinkers," which contained all the "Great Ideas." He thought "The Grove" was perhaps the best idea he had ever had.

Although he was a tough old bird, Warden Coots loved these magical Sundays. These special visiting days possibly meant as much to him as they did to any of the inmates. He enjoyed watching them every Sunday through binoculars from his third floor office.

From his perch on high he could observe the people who made his life interesting: Hack and Bella Waslonski playing hide and seek with their kids and then sprinting toward "The Grove" when they got the chance... Allie Sachs under an oak tree eating acorns and reading *Geek Love*... Oscar Nerlman taking a deposition from Judge Spencer... the Garbanzo twins exchanging clothes in the bushes... Icey Kool Jazzy Zee and some friends doing their thing on the basketball court... the Keatings, no doubt on their knees, deep in prayer somewhere out of sight. It wasn't exactly Camelot, but for Coots it came pretty close to it.

They were, after all, all he had. This pathetic little family of poor sinners. His flock, so to speak.

On this particular Sunday night the title of his autobiography, which had so far eluded him, came to him—"The Good Shepherd." That's it! "Good Shepherd," perfect! It was *him* in two little words. He put down his binoculars, picked up his pencil and went to work.

Warden Bubba Coots wrote on into the early morning hours. When the writing valve in his brain closed shut, he yawned, stretched, scratched his belly, and shuffled into the tiny bedroom behind his office. He poured himself a healthy slug of Jack Daniels, put on a videotape of *The Birdman of Alcatraz*, and drifted off to sleep.

＊

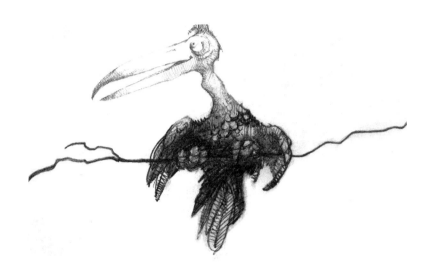

JAMES J. AUDUBON

✻

When viewing one of his prints
not even one of them hints
seeing anything feathered
he captured and tethered
then flew it
then slew it
then drew it.

I THINK ABOUT YOU,
THEREFORE YOU ARE.

THE SAILOR'S
NIGHTMARE

❋

O' curse'd ship. O' damned and wretched crew. Condemned forever to endure "The Sailor's Nightmare."

To sail your vessel aimlessly in a cold indifferent sea, pointlessly and without purpose, with a worthless cargo, unwanted in every port.

Who could have guessed that this premise would make a star out of Gavin MacLeod and millions of dollars for Aaron Spelling?

THE
ROAD

Ambrose Binks, the poet-philosopher-shoe sales-man, marched to "a different drummer," and he marched to that drummer down "the road less traveled."

Unfortunately, he had been mugged three times on that road—the last time by the drummer himself.

The road was so less traveled that he lay there unnoticed for what seemed like several days.

Ambrose vowed that if he were to recover, he would stay on the brightly lit, well traveled, heavily policed road from here on in.

ON SAFARI

❋

Teddy Roosevelt, Rough Rider hero of San Juan Hill and past President of the United States, died a very unhappy man. He had failed to kill all the wild animals in Africa while on safari there. This had plunged him into a hopeless depression. Some say that it contributed to his passing.

The scene of Roosevelt's last night was not unlike the last scene in Orson Welles' did in *Citizen Kane*—the biggest difference being that instead of whispering "Rosebud" on his deathbed, Roosevelt had whispered,

"Giraffe!"

Curiously, a book of Asian recipes had been found under his bed the morning after his last night. Underlined was a formula for a potion that called for *"boiled bear parts, powdered rhino horn, and pickled hippo gallbladders."* According to the Chinese pharmacist and fry cook who wrote it, it promised to "turn a callow boy into a virile, macho man." As you can see, Roosevelt had underlined "virile" and "macho." Those attributes are very important—especially to a Rough Rider like Teddy.

No one knew exactly what he had meant by "Giraffe!"

After a reasonable period of mourning, his heirs

demanded that the hundreds of sealed crates in the Smithsonian be opened and inventoried. The carcasses found in the safari crates kept twenty Washington taxidermists busy stuffing and mounting endangered species clear into the Hoover administration.

True to his personal code when he was in office, President Roosevelt "walked softly and carried a big stick." This came in handy once when he surprised a chipmunk on the White House lawn. It is now stuffed and on the mantle in the Lincoln bedroom.

Many years later, the American writer Ernest Hemingway traveled to Africa on safari and tried to kill everything that Roosevelt had missed. He interpreted Roosevelt's deathbed "Giraffe!" remark as a personal message to him to wipe them out. Call him a hopeless romantic if you like, but he did his level best.

After all is said and done, there is just so much even a virile, macho man like Ernest Hemingway can achieve in one lifetime. Between writing novels, bullfighting, and hunting and killing so many *other* wild creatures, it is not surprising that there are still plenty of giraffes left alive today. This in spite of the best efforts of our country's two most celebrated and macho big game hunters.

Incidentally, I journeyed to Africa recently on a photographic safari. Allow me to give you a helpful hint: if you should ever go there yourself, be sure to bring a close-up lens because sometimes you can't shoo the animals far enough away to take a decent picture.

Sir Roger Jettison
1832-1911

The inventor of throwing things overboard.

LETTER TO THE EDITOR

The time has come at long last to expose the shameful French Impressionist rip-off.

As we all know, the Impressionist painters painted their pictures in a unique way.

They painted in bold brushstrokes of unbroken color placed side by side so that the viewer would visually blend them, thus completing the paintings in his mind's eye. So, in effect, we the viewers must finish these pictures.

I'd like to ask a very simple question. Why should *we* have to finish these pictures for them? Is it any wonder we're so exhausted when we leave a museum?

And another thing, why did the artists sign the paintings if they weren't even finished?

It's like the philosophical question that asks, "If a tree falls in the forest, and no one is there to hear it, does it make a sound?" It's the same thing with Impressionist paintings. Are these paintings finished if there is no one there to look at them?

Of course not!

I suggest—no!—I demand that museum directors, who are well aware that they have hundreds of these unfinished paintings just hanging there waiting for *us* to come in and finish them—Mr. Museum Director, either remove them from your walls or have someone come in and finish them.

Enough is enough!

Sincerely,

Ralph Nader

They also serve who merely stand and stare.

THE CONDO
OF BABEL

✳

Henry David Hooper had a cognitive reasoning disorder which quite naturally led him to the study of comparative religions. He began his study by traveling to the world's centers of worship. He wanted to find out if a person's religion was based on heredity or personal discovery. He searched for an Irishman who worshipped in the Greek Orthodox Church. He couldn't find one. Eskimo Muslims were, as far as he could determine, virtually nonexistent. And Hindus in Norway were rarer than Jewish Apaches. He concluded that maybe the apple *didn't* fall that far from the tree, so to speak. At that early stage in his studies, Hooper was inclined to agree with Schopenhauer— "Religion is the masterpiece of animal training."

No study of comparative religions would be complete without a trip to the Holy Land. That unique place where people of all religions can get together and kill one another. He went there and spent two days pinned down in a three-way crossfire at the foot of the Ecumenical Peace Monument. He would have loved to visit the Wailing Wall, the Dome

of the Rock, and the Garden of Gethsemane, but he had to return his flak jacket and helmet to the nun who had lent them to him.

Hooper then traveled to Jonestown in Guyana. It became obvious to him there that what separates a cult from a major religion is the architecture. And then he thought about the Reverend Jim Jones. How could 980 people all be talked into *jaywalking,* much less murdering their families and then killing themselves? Fratricide, matricide, infanticide, and suicide—he wondered what, except for the passage of time, was the most significant difference between Masada and Jonestown? One thing's for sure, you couldn't question their sincerity.

Hooper had studied *The Protocols of the Elders of Zion* and *The Confessions of St. Thomas Aquinas* and didn't see that much difference between them, to be quite frank about it. History indicated to Henry that Caesar had crossed the Rubicon to conquer Gaul, Hannibal crossed the Alps to conquer Rome, and St. Paul crossed the Greek with the Hebrew and came up with the Catholic. He discovered that Confucius not only agreed with most of the Sermon on the Mount but had given pretty much the same speech 600 years earlier to a bunch of Chinamen.

Henry David Hooper sought clarification of this and many other things when he visited Vatican City.

"Jesus loves you!" said Father Mozzarella.

"Then why does he want me to go to hell?"

"He doesn't want you to go to hell. He wants to forgive you."

"He does? For what?"

"Your sins."

"Which ones?"

"All of them."

"Gee, what a nice guy."

"But first, you must seek redemption through suffering."

You mean I have to *suffer* to stay out of hell?"

"That is correct."

Hooper thought to himself "I'm puzzled," and made a note of it in his journal. The gentle Christian Father then spoke of forgiveness and salvation and assured him that if he blasphemed he would burn in hell forever. He was then told it was important that he love his neighbor.

"My neighbor is a prick," Hooper thought to himself and scribbled in his notebook, "*you* love him, I can't."

He *did* love the Catholic Church though. They had the best buildings and paintings, the fanciest outfits, and they drank booze in church which he thought was neat. But he always had a little trouble with that virgin birth thing.

The Christian yearning for everlasting life sounded good to him at first, but after a twenty minute discussion with a Hindu Untouchable in Calcutta he was not so sure. And later on, in airports, his in-depth interviews with Hare Krishnas were enlightening and insightful. He found the Rastafarian barbers on the island of Tobago articulate but lacking that certain "Je ne sais quoi." that was so important when searching for the spiritual meaning of life.

Later, seeking wisdom in the isolated caves of the

Himalayan mountains of Tibet, Hooper's research took an ugly turn. A Buddhist monk, hearing of his work, broke a twenty five-year vow of silence to call him an asshole.

Returning to the United States and traveling across the vast expanse of Oklahoma's prairies, he decided the time had come for him to actually test God himself. He sent Oral Roberts a check that would save him from a March 12th "Call to Heaven,"and stopped payment on it March 14th.

At the end of his studies, Henry David Hooper had, as all theologians before him had, accumulated a prodigious knowledge of the unknowable. He sensed a need in people ... a need to arrive at a Conscious Something from a Senseless Nothing drawn from conflicting Vague Possibilities... all this, in order to come down on the sunny side of doubt. Hosanna! Hosanna! 'Nuff said!

All of the doctrines he had researched were based on the premise that man is either born basically good, or that man is born basically evil. He realized that the truth is, man is born basically nuts! It was this knowledge that enabled him to gain entry into what he considered a "Nirvana of the Deep Thinker," which embodied the deeper spirit of the "Brotherhood of Man." Now, Hooper sleeps well. For when he kneels at his bedside and says his evening prayer, he cheerfully makes promises he has no intention of keeping, to a God he doesn't really believe in.

❄

SILENCE
IS GOLDEN

✸

"Silence is golden," said Jackson Peabody.

" ," Hazel replied.

"And the less said the better," he added.

" ," she agreed.

"Actions speak louder than words," he observed.

" ," Hazel replied as she took her clothes off.

"Now you're talking!" Peabody shouted.

I DON'T THINK, THEREFORE I AM NOT.

KOZLOWSKI'S

BIRDS

❋

West Virginia is craggy and full of v-shaped gorges and valleys. "It's a wonderful place to work," runs a local joke. "When you get tired you just lean up against it." But the truth is that there just wasn't much work of any kind for Mack Kozlowski.

To keep the family together, Mack's wife Bella earned a meager income raising miner's canarys for the Blue Ridge Coal Co. The miners used these fragile birds to test the amount of methane gas in the air in mine shafts deep underground. If a little canary suffocated, the miners knew they had about four minutes to get out of there, or the same thing would happen to them.

Over the years, Bella had somehow managed to breed a very hardy strain of canary that actually outlived most of the miners in the shafts. The Blue Ridge management loved them. The United Mine Workers of America did not.

As a matter of fact, the union made Bella's birds their top priority when a new contract was being negotiated: "No Kozlowski birds!" And while not actually bringing management to its knees, labor did prevail—no Kozlowski birds!

The union considered it a triumph of collective bargaining, even though it did have to give up hefty pension benefits in return.

It all became moot when the company switched over to strip mining, and Mack, his family, and birds became what might be termed victims of progress.

He tried marketing Bella's birds through the mail, but there just wasn't much demand for, as his brochure promised, "Little leather-lunged canaries that love the dark." Then, trying to pass them off as yellow rock Cornish game hens didn't fool the buyer at Piggly Wiggly, so Mack just opened their cages one day, and off they flew. That was twenty years ago, and the Audubon Society reports occasional sightings to this day.

TRIUMPH

OF WILL

✻

In Vienna, a blindfolded ten year old, Will Testi, played chess with fifty world grand masters simultaneously.

He won twenty-four games and lost ten. The sixteen boards he knocked over were not counted as wins or losses.

He hated to second guess himself, but if it hadn't been for the blindfold, he felt sure he could have knocked over the ten boards he had missed.

THE
WEDDING

*

The honor of having Ralph Nader give away the bride was only slightly diminished when, walking down the aisle, he quite audibly remarked that because of the construction of the cathedral by obviously incompetent architects who had built this deathtrap in 1723, they would all be lucky if they lived through the ceremony.

Everyone noticed that the bride's slip was showing, but Ralph was the only one who decided to write a book about it.

It was understandable that this distraction caused him to trip on his untied shoelaces two-thirds of the way up the aisle. I feel it was a tribute to his charisma that neither I nor anyone else laughed out loud when he approached the altar on all fours, followed closely by the lovely young bride.

The vows were touching.

The two young lovers were so in love.

Ralph pointed out that both wedding bands were "out of round." But as you might expect from this kind man, he decided to postpone the exposé until after the honeymoon.

PETER

PAUL TURPS

※

Peter Paul Turps, the artist, had just had his first
New York one-man show. Unfortunately, that
was the attendance.

The next day, the newspaper critics' reviews of his work
were disheartening. "Nuance," "chiaroscuro,"
"juxtaposition"—words that appeared in *every* art review were
not used even once in his. The term "copycat," however did
appear in *all* of them. To Turps, a media conspiracy was bla-
tantly apparent. He hadn't felt this low since the time thieves
broke into his studio in the middle of the night, looked
around at his paintings, and stole his stereo.

This is certainly not what he had expected as an idealis-
tic young art student in Paris. The Parisian fast lane was
made to order for Peter Paul Turps. He was high on life—
and booze, and drugs, of course. He frequented all the fabled
haunts of the great artists—Toulouse-Lautrec, Degas, Renoir,
Gauguin. Things must have been different in the old days,
because when Peter tried to pay his bar bill by drawing a pic-
ture on the tablecloth, the Moulin Rouge added $14.00 to his
tab for defacing restaurant property.

Like Oscar Wilde, he drank "to make other people more
interesting." Sometimes he found them so interesting that he

passed out altogether. He began throwing too many parties where he was the only guest. After searching the very cirrhosis of his being, he decided to live out what remained of his signature years in Spain, the land that inspired the twentieth century's greatest artistic industry—Pablo Picasso.

Spain was everything he had expected. But that surprise vasectomy he got running with the bulls at Pamplona had taken something out of him, and his mood swings now reached epic proportions.

It was time to move on. He was getting very good at moving on.

Arriving in the cultural center of the United States seemed to revitalize him. He loved Los Angeles.

With the help of a very creative resumé and a flattering letter of recommendation from a hooker in Madrid, he fit right in, and even prospered for a time. But this morning's news was almost more than he could bear.

The one work he was sure would one day guarantee him a place in the pantheon of great art, a master among masters, was going to be plastered over. That's right, his mural, *The Last Brunch,* in the Cathedral of St. Vacuous of Hollywood, was to be destroyed.

What a limp excuse Father Ricky gave for his insensitive destruction of a sublime work of art. "The Archdiocese expected a fresco. Why would you paint it with day-glo on black velvet?" he said in that "holier than thou" way of his. "And having *The Last Supper* take place at the Polo Lounge is nothing short of blasphemous!"

Turps was numb. He had put so much of himself into that work. There was "juxtaposition" aplenty, more than enough "nuance," and "chiaroscuro" to kill a horse. To cover all the bases, he even made sure it was didactic, eclectic, and derivative, making use of all the terms he had mastered in Art Babble 101.

Unappreciated, underfed, and unable to work, he brooded in his cold lonely loft. "How could the world ignore such an original creative genius?" he wondered.

Then, just as it had happened before when he thought he had hit rock bottom, a surge of creative inspiration swept over him.

"I've got it. That's it!" he shouted as he rushed to his easel and grabbed a palette knife.

"OW! OHWEE! OUCH! OK! There! That should do it! The cover of *Time! Larry King Live! Hard Copy! Prime Time Live! Oprah! Geraldo!* The cover of *People!* Maybe even *Regis and Kathie Lee!* The sky's the limit!" he said gleefully, as he reached down and picked up his left ear.

THE STENCH

OF ELEGANCE

❋

The Annual Snob Picnic was held at the Tomb of the Unknown Maitre D'. This year's crusade was aimed at stamping out between-meal snacks.

"All this fuss about hunger," said Pam, "makes me sick."

"Yes, my little pigeon," Cecil agreed. "If people are really starving, then why are there empty tables in restaurants?"

Pam and Cecil Essex were stupid, but they were too well dressed to notice it.

Cecil's valet was able to do wonders with the eight hairs growing on Cecil's head. He let each one grow seven feet long,

then, by cleverly crisscrossing them back and forth, made Cecil look at least as good as Sam Donaldson.

The Essexes had joined Time Wasters Anonymous, and after a decade of being merely vacuous, Pam judged a warthog beauty contest and had gotten a sort of high from the pointlessness of it. That first "apathy rush" was seductive.

It's a familiar story. That first seemingly harmless "trip" led to disinterest, and then downhill to "total unawareness," a condition which they had to be reminded they were suffering from. They took it very well.

They said they "didn't care."

It all seemed so super tragic.

✳

GIUSEPPE'S

✳

I'd like to order a small cheese pizza, please."

"We don't got a small cheese pizza. We just got medium and large size pizza."

"Yo! Well then, I'll have the small one."

"Don't you understand English, jerko? We don't got a small size pizza—just the medium and the large size pizza."

"If you only have *two* sizes how can you have a *medium* size pizza?"

"Because we do! That's why, dickhead!"

"Hey, OK. Then I'll just have a Diet Coke."

"Large or small size, tough guy?"

"Umm... medium."

✳

A seeing eye greyhound.

81

SPEAKER'S
CORNER

❋

Hershell Nerlman regained consciousness in his
cell. The last thing he could remember was
shouting to the crowd, "Let he who is without sin cast the
first stone."

He was covered with welts and bruises from the shower of rocks that had followed. To make matters worse, he had been arrested for inciting a riot.

More disturbing was the fact that he would be judged by a jury of his peers. He felt uneasy having his fate in the hands of a bunch of degenerates. The trial was a sham. The guilty verdict came as no surprise.

Allowed to make a statement before sentencing, he defiantly shouted, "Give me liberty or give me death!"

"Have it your way," said the tribunal and changed the thirty-day sentence to death by hanging.

"I regret that I have but one life to give to my country!"

"So do we," answered the judges, "Round up his family!"

Climbing the stairs of the scaffold with Nerlman's family, the priest at his side was trying to offer comfort, "Lo that I walk through the valley of the shadow of death, I shall not fear—thy rod and thy staff shall comfort me. He has trampled out the vintage where the grapes of wrath are stored... Thou shalt not crucify mankind on a cross of gold."

"Please Father, enough! That's the kind of gibberish that got me into this mess," Hershell said from under the hood as they placed the rope around his neck.

*

VINNIE

❋

As he regained consciousness, he remembered the last thing he said to Gloria Steinem.

"A woman, a dog, and a walnut tree... the more you beat them, the better they be."

In the mirror, he could see on his head what looked like the imprint of a high-heeled shoe.

❋

*Thomas Alva Wooley, inventor
of the Phillip's Head Dildo.*

Mona Shamm, founder and past president
of the Fake Orgasm Society.

THE
GREAT IDEAS

✳

I have just finished reading *The Great Ideas of the Deep Thinkers*, and realized that really there wasn't one great idea in there that I hadn't thought of on my own at one time or another.

So Voltaire, Montaigne, Nietzsche, Schopenhauer, Spinoza... what separates them from me? Many things. First of all, when they got a great idea they wrote it down. Second, they wrote it down before anyone else did. I, on the other hand, found it difficult just finding time to *read* the *Great Ideas,* much less write them down before anyone else did.

That is going to change. From now on whenever I get a "great idea," I'm going to write it down. The following is a smattering of my wisdom, of which there will be much more in the years to come.

✳

I may disagree with what you say, but I will fight til the death for my right to prevent you from saying it.

I feel at one with the universe. It is expanding, and so am I.

Oh sure, I have second thoughts about the meaning of life. But except for that, I have everything else figured out.

I've noticed that when I keep my head when those about me are losing theirs, the chances are a war is about to break out.

Socrates was wrong! The "unexamined life" is well worth living.

Stuff your turkey with popcorn—when the tail blows off, it's done.

Could this work? Expel all the Palestinians from Israel, the West Bank, and the Gaza Strip—every one. Then expel all Jews from the United States. Jews to Israel, Arabs to America. Presto! Zionists happy! Arabs happy! Wherein lies the flaw?

A view is just a page you cannot turn.

If it weren't for Thanksgiving, there would be no reason for November.

Life is short. Eat up!

My grandfather told me that you can't have more than a good time.

It takes a big man to cry. It takes an even bigger man to laugh at the man who cries.

Is there a sadder sight than a fifty-year-old busboy?

I am old enough to remember when soy sauce was an exotic Oriental spice, and rice was something only starving people ate.

*Nature abhors a vacuum
cleaner salesman.*

Every once in a while, a possum really is dead.

I have taken an oath of celibacy, but I'm not going to be a fanatic about it.

Isn't it interesting how foolish the uniforms of other countries look?

Albert Einstein said, "Against every great and noble endeavor stand a million mediocre minds." I opposed him on that.

If environment is so important, why aren't there more Eskimo figure skaters?

George Bush never really convinced me that Saddam Hussein was just like Hitler. I thought Saddam Hussein was more like Ernie Kovacs. Hitler had a little square moustache. I think Hitler was more like Charlie Chaplin.

What is the synonym for thesaurus?

The universe is expanding. So what?

Is it possible that Dreyfuss was guilty?

I do not believe in capital punishment, except in the case of the man who sold those derby hats to all the women in Bolivia.

Friends come and go; enemies accumulate.

Am I right on this? Jockeys' heads are too big.

For many years my brain was attached to my genitalia.

A bad person with a sense of humor is not such a bad person.

The Christian religion declared the naked human body obscene. This before ever having seen me nude, thus illustrating their gift of prophecy.

I wouldn't live in New York for twenty million dollars. However if I *had* twenty million dollars I wouldn't live anywhere else.

It was very nice of the French to give us the Statue of Liberty. It would be even nicer of them if they stayed in Canada where they belong.

Orange is the navy blue of India.

Where is H. L. Mencken when we need him?

I drink no wine until *I* am at room temperature.

How come there are so many colleges and all I seem to meet are illiterate morons?

Being a bedwetter is one thing but going from room to room is another thing altogether.

The two most motivating influences at this stage of my life have become jealousy and revenge.

THIS TOO SHALL PASS.

We beat the Russians to the moon, and one day they will be joining us there. They, on the other hand, beat us into bankruptcy. We will be joining them there very soon, I assure you.

Who were the greatest Buddhist conquerors? I've looked. I can't seem to find any.

If the archaeologists are correct that life on earth is two billion years old, it's possible that God has lost interest and gone on to bigger and dumber projects.

Five or six times doesn't mean you're gay.

I am offering a hefty reward to anyone who can name the ten most beautiful Cubist paintings.

The strapless Velcro g-string.

For a while there, in the Holy Land, it was safer to hit Tel Aviv with a Scud Missile than to throw a stone at a truck.

What a relief that the outcome of the Cold War proved that God was a capitalist. What if he had turned out to be one of those fucking humanists?

Most of the people who talk about "free speech" never say anything that would be banned anywhere.

Henry Kissinger got the Nobel Peace Prize for prolonging the Vietnam War for seven years.

No one has ever seen an underweight Samoan.

Lipstick on your collar is one thing, but eyelashes in your shorts is another thing altogether.

The polls indicate that most Americans think their government is inept at everything except killing foreigners.

Thirty years ago you couldn't say the word "pregnant" on TV. Last week on *Good Morning America*, Dr. Ruth Westheimer demonstrated how to maintain an erection.

I am willing to pay big bucks for a tape of a professional golfer saying something interesting.

There are few things as universal as laughter or as educational as pain.

"What Hall of Fame baseball player said "I dedicate that Home Run to my Lord and Savior, Jesus Christ.?"
"Hank Greenberg?"
"I don't think so!"

To say that "Mexicans are no better than Jews," may be true but somehow it doesn't sound the same as saying that "all men are created equal," does it?

Never try to teach a Doberman Pinscher to "sit up."

You just don't say "Heel!" to a sled dog.

I've tried but I can't name the ten greatest Hawaiian philosophers.

Blessed are the vague, for they haven't a clue.

There is a man in Oregon who claims to have a tape of Donald Trump saying something interesting.

History is not bunk—it's just plain perjury.

Sterilizing the medfly is working. I saw two of them humping yesterday and their heart just wasn't in it.

Reptiles and amphibians are coldblooded. During a heat wave do they huddle together to keep cool?

Once a religion becomes the government of a country, it should give up all pretense of representing universal truths.

The Cold War really ended when, after the Russians had spent 4,000 kazillion rubles on defense, that German teenager landed a Piper Cub in Red Square... unopposed.

Judge not until you've walked a mile in another man's dress.

It's possible that if Prozac had been available in 1890, Vincent Van Gogh might have been a very fine plumber.

A "traditionalist" is someone who, after intense thought and questioning, believes in whatever it was his parents believed in.

A country that can be proud of the invasion of Grenada can be proud of anything.

Honor your commitment to the universal brotherhood of man—but protect yourself at all times.

Censors are not talking Shakespeare, they're talking pubic hair.

I was very upset recently after reading an article in *The New York Times* on "The Dumbing Down of America." It's not as if I hadn't noticed. It's just that I thought I was getting smarter. After re-reading the preceding pages I'm not so sure.

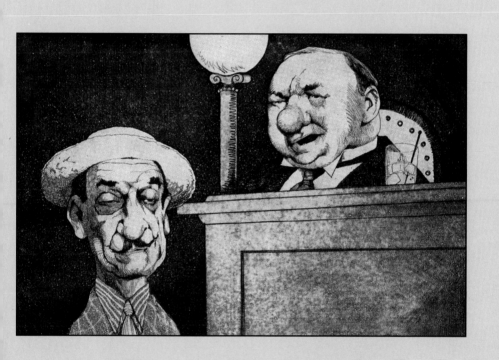

I DRINK, THEREFORE I AM.

BARON
de ROTHSCHILD

※

The *National Enquirer* was facing its most contro-
versial libel suit. In a front page banner head-
line they had reported that the Baron Phillipe de Rothschild
preferred the Colonel's Kentucky Fried Chicken to Tour
D'Argent's Coq au Vin. The fashionable international intelli-
gentsia was scandalized by what seemed a blatant case of
character assassination.

The dramatic proceedings on Court TV kept the whole
world in rapt attention for more than four weeks.

During Alan Dershowitz's relentless cross-examination,
de Rothschild broke down. He was quickly reduced to a
pathetic, quaking hulk. The case was about to be dismissed
when, to everyone's astonishment, the Baron suddenly rose
up and screamed, "It's true, I *do* love the Colonel's Kentucky
Fried Chicken!!"

"I object, Your Honor!" his lawyer shouted.

"Your Honor, it's no use," sobbed the wild-eyed Baron. "He's just trying to protect me. Yes, yes, I *love* the Colonel's chicken! *But it doesn't stop there...* Oh, God, help me!!...

"I *love* Norman Rockwell's paintings too! I treasure them more than *all* my Picassos and Miros put together!!

"And, and... listen to me! I *hate* Shakespeare! Is that a foreign tongue he's speaking? I get migraines at his plays...

"And... I've tried, I really have tried but I *can't stand* opera either! I can't help myself. It's ridiculous to me. Everybody stomping around, singing at each other at the tops of their lungs.

"And I cried, yes, I *cried* when Benny Hill died! He was the funniest man, wasn't he? Just the best. I miss him so. Doesn't everyone?... And... and... I laugh at the Three Stooges! I laugh real hard. I have tapes of every film they ever made, even after Curly died!

"I have the largest collection of Rothkos, Josef Albers, and Willem deKoonings in the world. Do you know who painted my favorite pictures?... *My God, what am I saying!!?...* Maxfield Parrish! It's true! And has Your Honor ever seen N.C. Wyeth's illustrations for *Treasure Island* or *Robin Hood?* They're just the greatest things... things that I loved when I was just a boy... I *loved* them Your Honor, and Oreo cookies! I'm sorry... I've said enough. Your Honor, I throw myself on the mercy of the court."

After the furor in the courtroom subsided, Judge Jonathan J. Barclay released the Baron Phillipe deRothschild on his own recognizance. He wondered if maybe in the future he and the Baron could maybe hang out together from time to time. That is, if it was OK with the Baron.

※

HOFF-HOFF

Professor Dr. Cosmo von Hoff-Hoff was heartbroken. A depressing pall descended on his Stanford medical research project. All his lab monkeys had gotten the flu and died before he could give them cancer.

This meant that the Nobel Prize Committee for Medical Research would once again overlook his work.

Year after year, his claims of miraculous cures had been dismissed by the rest of the scientific world.

Perhaps it was his insistence on using possums instead

of laboratory rats in some of his experiments that made it impossible to verify any of his results. One could never be sure which ones were really dead and which ones were acting.

To von Hoff-Hoff there was no doubt that his serums had actually brought them *all* back to life. His paper, *Death: A Temporary Frame of Mind*, not only was not published, but even Xerox machines refused to make copies of it.

His "Time-Release Placebo," which had taken him twelve years to develop had also been ignored.

What hurt so was that all his work was to benefit his fellow man. His desire to make the world a better place to live was too intense to diminish. Preventing a nuclear holocaust and its catastrophic devastation became an obsession. He would use all his brilliance and knowledge for the rest of his life to find an alternative to the destruction of civilization as we know it.

Progress on the new von Hoff-Hoff Quazee Lazer Ray was rapid. In its primitive stage it could only turn enemies into permanently blind quadraplegics, but it showed great potential nevertheless.

An article in *People* magazine on his work resulted in a Defense Department research grant of forty-eight billion dollars.

His flight to Stockholm was relaxing and gave von Hoff-Hoff the time he needed to polish his Nobel Peace Prize acceptance speech.

※

CALL ME

ISHKABIBBLE

※

The offspring of famous parents often have problems even in the closest of families.

As a youngster, Roldo had loved listening to tales of his illustrious grandfather. He seemed such an adventurous and fun-loving sort.

Roldo enjoyed the stories about how his famous grandpa would amuse the family by seeing just how far he could spit a human being.

Although he did it for sport, Grandpa still held the official distance record—Jonah had hit the beach about eighty-seven meters from where grandpa had expelled him.

The only family member that seemed strange to Roldo was his albino uncle, Moby Dick. He was paranoid and obsessed with the idea that someone was after him.

Roldo had to stop daydreaming now, Shamu had informed him that there were just five minutes to showtime.

?

✳

It was the ugliest display of bigotry the town of Greenville, South Carolina had ever witnessed.

The night before, a gang of agnostics had burned a huge wooden question mark in Reverend Bosley's front yard. They left a chilling note. "We can't make up our minds about what to do to you, and what's more, as good agnostics we never will."

As a Southern Baptist, Reverend Bosley felt helpless and confused. How should he defend himself against an extremist sect that would never be able to decide what to do to him?

It wasn't as if Bosley and the townspeople didn't know where the agnostics were. Their church, Our Lady of Indecision, was right next door to the atheist shrine, a vacant lot.

Across the street, was where "them Jews" had built their "Synagod." "In there studying their *Toro* no doubt," Bosley chuckled. He liked them. They kept to themselves and made the best rye bread he ever put peanut butter on. Too bad

they thought the Old Testament was the whole story.

Around the corner on Maple Street was St. Ignoratius, the Catholic Church, where they actually drank wine *in church!* What can you expect from a bunch of preachers who dressed up like girls?

Reverend Bosley's credo was, "Do unto others as they would do unto you." They were out to get him. He would get them first — it was the Christian thing to do.

As he was cutting eye holes in a new sheet, he figured that perhaps he and the Grand Kleegle could come up with some countermeasures at tonight's midnight rally in Rastus T. Jefferson's front yard.

※

BON VIVANT

Hale fellow well hung
perched atop life's bottom rung.
No toupe but lots of plugs,
high on life and booze and drugs.
Fixed grin and girth like Limbaugh
searched in vain for a world class bimbaugh.
Zero luck with video dating
Computer result, point 0 rating.
When he got that news right after work
he gave his love noodle a sympathy jerk.
Rejection had caused him severe psychosis
to say nothing of his advanced cirrhosis
He passed away on an aging Futon
with his hand on his dick and just one boot on.
With lust in his pants and nothing in his head
I think we agree, he's better off dead.

CORKY H.S.G.

※

All things are possible to he who has a dream."

This certainly seemed true to Corky Conroy H.S.G.

The grand opening of the Metropolitan Museum of Honolulu and Library was his creation.

Even though he was an H.S.G.—High School Graduate, he couldn't have done it alone.

The prominent citizens of Hawaii, whose civic pride had been aroused by the project, were generous beyond his wildest hopes.

The Hall of Culture became a reality when the wealthy Maxwell Dole from the islands of Maui and Lanai donated his entire private art collection to the museum.

Those six coconuts carved like faces were the nucleus of the permanent collection.

Don Ho's donation of 5,000 pounds of books as well as 10,000 tiny bubbles put to rest those rumors that he was an asshole.

From the mainland, Ross Perot's donation of eighteen running feet of red books was the most impressive contribution from a "howlie."

The museum's "jewel" was beyond a doubt the priceless exhibit that traced Hawaii's heritage—from the ancient past when God dropped those five huge Seconals into the middle of the Pacific Ocean, right up to the first little umbrella to be served in a drink.

In the library rotunda, displayed under glass, rested the original manuscript of Robert Louis Boner's breakthrough analytical paper, *More Than Pineapples: An In-depth Study of the Great Hawaiian Philosophers.* Some critics say it may be the most profound two pages ever written on the subject.

Professor Boner was scheduled to be the main speaker at the ribbon cutting, but he must have gotten lost on the way because it was almost dusk and he was nowhere to be found.

Corky hated to leave the opening ceremonies but the word was out. The surf was up, there was going to be a fabulous sunset tonight, and he didn't want to miss either one.

※

CABLE

✳

My grandmother and our cable TV connection arrived at our house the same day.

At eighty nine years of age, the trip on that Greyhound bus all the way from Nebraska had left Grandma fatigued and weak. I brought her some cocoa and made her as comfortable as I could. I turned on the TV.

There was Robert DeNiro in *Taxi Driver* screaming, "You motherfucking scumbag, here's your loyalty!!" as he grabbed his balls and shook them at Jodie Foster.

I tried to change channels quickly but I was too late.

God love her. We will miss her.

The service was brief but beautiful. How touching that Grandma's remains were to be returned to a lovely peaceful place behind that little one room schoolhouse in North Platte where she had learned everything she knew.

✳

WALDO

THE ORPHAN

WARTHOG

❋

One awful day, deep in the forest, Waldo the baby warthog was orphaned by poachers. Tiny and helpless, he would surely have perished had he not been adopted by a family of gorgeous snow leopards.

Heather, the beautiful mother leopard, cared for him with the same tenderness and love she gave Shareene and Sharelle, her adorable newborn twins.

Waldo was an ugly little warthog, and the other young animals mocked him with insults, made fun of him, and would not play with him. He was an outcast.

Sweet Mother Heather, who loved him, comforted him with the same bedtime story every night. It was the story of *The Ugly Duckling...* the ugly little duckling who was also an outcast, but who grew up to be a beautiful swan.

Mother Heather never tired of telling this story to her offspring night after night.

But she noticed that, as time passed and they all grew up, instead of getting prettier, Waldo was actually getting uglier and uglier.

So much so that even she couldn't stand to look at him, so she took him deep into the forest and abandoned him — where he died of loneliness and a broken heart.

※

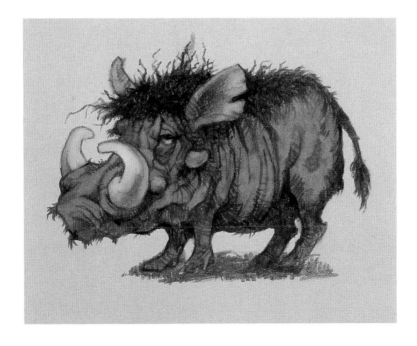

BOLLO

❋

Bollo, the wild donkey had dressed himself in a lion's skin for protection from predators. One day, while grazing in some tall reeds, he was confronted by Marlon Perkins and his film crew from *Wild Kingdom*.

He had seen them before and knew that a struggle meant a tranquilizer dart in the rump, so he allowed them to put a radio transmitter collar around his neck without a fuss.

That spring, Bollo the donkey (still in disguise—the radio collar holding the lion skin fast around his neck), was tracked and filmed to better understand the mating habits of lions.

The incredible footage of a lion mating with a wild donkey astonished zoologists all over the world. There had never been a known instance of "the king of beasts" ever cross breeding with a donkey before.

Every renowned naturalist in the world descended on the jungle to observe the birth of the first of a rare new species.

Bleachers were set up for film crews from CBS, NBC, ABC, PBS, CNN, the AFL, and the CIO.

John Forsythe and David Attenborough got into a fist

fight with Peter Arnett over a particularly good patch of jungle growth that they wanted to stand in front of while narrating their TV shows covering the great event.

The surprisingly easy birth of "Little Willie" was received with great joy and relief by an anxious and concerned world.

After appearing with Jim Fowler on *The Tonight Show,* and in a cover story in *National Geographic,* Bollo and his offspring, Little Willie, the unprecedented "half lion" (*all* donkey) went on exhibit at the San Diego Zoo where they attracted huge crowds that were delighted by their uniqueness.

D M Z

✻

I t was the 97th year of the peace talks here in the
"Demilitarized Zone."

The constant deafening bombardment made it impossi-
ble for either side to hear any of the peace proposals that were
being offered, or the rejection of them that always followed.

A breakthrough occurred when both sides employed the
services of lip readers at the conference table. But actually
knowing the other side's proposals only served to harden their
positions.

The war had raged on for 347 years. Both camps had suf-
fered colossal casualties and personal sacrifice, and both sides
had exhibited many acts of individual heroism.

The front lines stood less than 100 desolate yards from
where they had been when the war began.

The major challenge was how to word a peace treaty so
that each side could interpret it as "unconditional surrender"
by the other side. This was because pressure groups back
home had to be appeased. "The Scorched Earth Society," "No
Prisoners R Us," and the "Legion of Noncombatants" would
settle for nothing less than total victory.

The conflict started when the crossbow was considered

118

the ultimate weapon and raged on through and beyond the development of tanks, atomic bombs, and biological warfare. There seemed to be no light at the end of any tunnel.

Each side hoped for a breakthrough that would bring the enemy to its knees with the "ultimate weapon."

Herman Shafner, the fashion designer of the Nehru jacket and leisure suit was perhaps the least likely person to bring this awful conflict to an end. But that is just what he did.

He designed the "ultimate uniform"—a uniform that makes it look like you're advancing when you're really going home.

THE

DREAM

※

I awoke trembling uncontrollably from a horrendous nightmare. My blood still runs cold when I think of it. Imagine this if you can...

All of America's professional golfers organizing a revolutionary cadre of malcontents out to change our system and threaten our beloved way of life. Then, as you might expect, dissatisfied tennis pros join their crusade for justice and brotherhood (which of course is their heritage).

"The Golfers Revolt for Social Change and Tennis Pros," was bad syntax but was (in my dream) not just another terrorist fringe group whistling "Dixie." You don't laugh at radical activists responsible for the 6 a.m. tee-off time, as well as the two-stroke penalty, for the slightest hint of empathy for the less fortunate (those without golf carts). Their cherished "Veneer Trophy" went to the country club that most nearly seemed to have its finger up the pulse of America.

It wasn't long before the fever of revolution spread west to the investment bankers, choreographers, manicurists, and aerobics instructors. It was a sorry day for America when baton

120

twirlers and surfers joined the anarchist mob that stormed down Rodeo Drive and presented the doorman at Gucci's with a declaration of their demands — a better, more just way of life for all of mankind.

When I awoke it still puzzled me that such a dream, one without bloodshed or violence, could still have such a traumatic effect on me after all these years.

WAH TA NAH HO

＊

Wah Ta Nah Ho, the hunter, came to a spring—a pool of water. As he was drinking, he saw his own reflection in the water and fell deeply in love. He fell so deeply in love that he wanted to gaze at his image every waking moment.

His rapture was interrupted by the ripples caused by birds landing, deer drinking, and the fish in the water. Disturbing the stillness of the spring caused his lover to disappear.

Wah Ta Nah Ho was a great and noble hunter, so he set about to remedy this. Instead of hunting just enough game to provide for himself and his tribe, he would also eliminate all the offending creatures who caused his heartbreak.

In time there were no birds, no deer, and no fish.

The pond was now so still and mirror-like that he could gaze endlessly at what had captured his heart. It was paradise— all the wildlife intrusions had been eliminated. And with all of them gone he had nothing to hunt so he had even more time to enjoy the magnificent visage he so adored.

His starving tribe had long since moved on.

So deep was his love that even his hunger was of trivial concern.

His devotion and ardor did not fade even when his lover became thinner and thinner. And as his beloved began to look sick and weak, he himself became ill at not being able to help.

He grew weaker but never left the pond. He would stay with his love to the end.

The last thing Wah Ta Nah Ho thought as he pitched forward into the water was that his beloved not grieve for long but carry on and live a full rich life and remember him with fondness occasionally.

※

WALDO

❄

I was just kidding about Waldo the orphan warthog.

He's still ugly. But alive and well, and living with a very nice repulsive family of warthogs.

He is dating a very unattractive young sow, whom he hopes to marry, and with whom he plans to raise a large grotesque family.

TYCHO

※

Tycho Bronzini is the most brilliant young fashion designer in all of Italy.

This year's festival will feature his creations, an unprecedented honor for one so young.

The most important and influential trendsetters from every corner of the world will be there. To dazzle and impress them, Tycho had to call on all of his creative genius.

He imported linens from Austria, Belgian lace, silk and satin from the Orient, velvet and damask, ermine from Sweden, and Russian sable, all to be used by the finest tailors and seamstresses.

At last the day of days is here.

The tension is almost more than Tycho can bear when he arrives at the festival. So many famous and beautiful people, everyone he has ever read about or hoped to see is there.

He is trembling with anxiety. Surely he will faint.

There is a rippling of applause at the back of the crowd.

The huge bronze doors open to the long ramp.

The applause swells, turns to cheers, and then to bravos.

Everyone is standing now, ecstatic at what they see.

Tycho Bronzini is sobbing with joy. He is the happiest man in the all the world.

Pope John XXIII has never looked lovelier.

THERMO

❋

On a seldom read page in a remote corner of *The Guiness Book of World Records,* lies a chilling tale. The cold statistics are accurate to be sure. But let me tell you the incredible flesh and blood story behind the numbers. The story of Thermo, the unluckiest polar bear in history.

There are 5,541,000 square miles in the Arctic Circle. There are 10,000 polar bears who live there.

When Thermo was just a furry little youngster, *National Geographic* tagged his ears to track the migration of polar bear cubs. The constant headache the tags gave him was distracting. At that tender age, he thought that was how he was supposed to feel. Some years later, as an adolescent, while eyeing girl polar bears and feeling strange feelings, a helicopter from MIT dropped a dye marker on his rump.

In the Arctic North, magenta is perhaps the ugliest, most out of place color imaginable. To have it permanently covering your behind did not make a naturally hard life easier. As a matter of fact, mating was impossible, so repulsive was he to girl polar bears.

Thermo welcomed long winter hibernating as relief from the rejection and hurt. His constant headache made dozing off difficult, but finally he did.

He was awakened by a humming sound.

TV's *Wild Kingdom* had put a radio transmitter collar around his neck while he slept.

Winter hibernation was supposed to last another month, but try as he might, that hum kept him awake.

In the spring he was sluggish and drowsy. He had constant headaches and was ashamed of his appearance.

Thermo's story is a small one. What does one polar bear's misfortune matter in the overall scheme of things?

Hindsight is easy. Scientists studying the behavior of *all* polar bears were misled for decades by monitoring just one unhappy one. And that is why today so many of us know so little about a subject that no one is interested in.

W O N G S

⁕

Wong's Chinese Restaurant had invoked the rule of "Eminent Chow Mein."

Their combination of an awful pun with a sense of American history indicated how effectively the "melting pot" was working.

I was surprised that the name on their passports read the "Longs."

I had known the Wongs for some years and did not realize they couldn't pronounce their own name.

Had I been wrong in calling the Longs "Wongs?" Did they prefer "Long" instead of "Wong," even though they couldn't say it themselves?

Did they think I was making fun of their speech impediment when I called them Wong?

In going along, was Long wrong not to tell me his pwoblem?

Surely, Mrs. Long was wrong to accept "Wong" as "Long" when she knew that two Wongs don't make a Long.

Mr. Long (Mr. Wong), did not take wong to decide something was wrong.

He suggested we go to an eminent psychiatrist, a Dr. Wy Oh for help.

My eyes strayed when Dr. Wy Oh was on the phone. They settled on the diplomas of... Dr. Lyle!

When they spoke to each other, Long called Lyle "Wy Oh," and Lyle called Long "Wong."

Here was my dilemma: to call "Wy Oh" Lyle, and "Wong" Long would be wrong.

So I must call them "Wy Oh" and "Wong" instead of Lyle and Long. There were no two ways about that.

I'll get to the bottom of this, or my name isn't Leland Lillianthal.

※

131

IN MEMORIAM

❈

As if in imitation of the United States, the government of Vietnam has announced that they plan to build a war memorial wall in their capital city almost exactly like the one we have in Washington, D.C.

Though it will be identical in all other respects, due to the difference in the number of casualties, theirs will be 3,000 times bigger.

❈

PINOCCHIO

❋

Pinocchio could hardly remember the last time he
had worked in show business. Things just hadn't
been the same since Gepetto died.

Let's be frank, it was the Muppets. They made it impos-
sible for anyone else to get work anywhere.

It was the same at every audition: "The strings, every-
body can see the strings." Or "Can you move a little
smoother? You look like a puppet."

How big a star you had been in the past didn't matter.
Even Howdy Doody had had to sell all his freckles and was
destitute.

Pinocchio was not bitter. But he was ashamed.

Just to survive he had purposely told lies to make his
nose grow and then sold the extra lengths to a clinic in
Dublin where they were transplanted onto the faces of little
Irish kids.

CONTEST

❋

An award of $100,000 is being offered for anyone who, when a controversial Constitutional issue arises, is able to prove the intentions of the Founding Fathers.

$200,000 in additional prize money will be awarded to anyone who can prove that, when it comes to deciding controversial Constitutional issues, it really matters *what* the Founding Fathers intended.

(All entries must be in writing.)

WILLIAM T.
WILLIAMS

✳

William T. Williams was on the witness stand at the hearings that followed the tragic loss of the *Titanic.*

Convincing the jury that he thought the PA system had said "William and children first," would require very skillful questioning by his attorney.

DUKE

✳

uke was a handsome little fellow. A mixed
breed with just enough Doberman in him to
get a wide berth from strangers on the street.

I was lucky to get him as a five-week-old pup, and he
was the spunkiest, cutest, and most lovable little guy you
ever saw. We would romp and play for the longest time,
and when he'd had enough, he'd just keel over and fall fast
asleep in my lap.

When he woke up, he was ready to get back at it again
right where we left off, as if he'd never been away.

Well anyway, after a week or so I drove him over to
the veterinarian's office and had his ears cropped. He
looked so comical when I picked him up, all wobbly, with
his little ears all taped up with little bamboo splints to
make them stand up straight.

The vet assured me he'd be back to his normal self as
soon as the anesthesia wore off. Sure enough, at home after
a long snooze, he woke up and ran right over to his bowl,
ate, and then wanted to play. What a game little guy.

A week later, I drove him back to have the tape

removed. His ears didn't look too good, sort of like two pieces of uncooked bacon.

Dr. Blalock was not concerned and said they would be beautiful when they healed completely. Then he cropped Duke's tail.

After a while I just didn't like the look of that stump so I decided to to drive him back to the vet.

Duke didn't seem to want to get in the car for some reason but I finally coaxed him in with the help of a leash and choke collar.

Once there, after a general checkup showed that he was OK, I had Dr. Blalock give him his rabies and distemper shots, and had him dewormed and neutered.

I don't know if it's possible for a dog to do this, but when he woke up he gave me what seemed like a dirty look. Duke never seemed the same after that. Sure, we still played together, but his heart just wasn't in it like old times.

One beautiful Sunday morning, I thought that a nice drive and a romp in the park would do us both good.

As I opened the car door, Duke must have seen a squirrel or something because he bolted and jerked the leash out of my hands, and disappeared up the block and around the corner in a flash.

I never saw Duke again. Gee, I miss him. He was the smartest dog I've ever owned.

I THINK SLOWLY,
THEREFORE I SUPPOSE I AM.

THERMO

REDUX

✳

The spring thaw ended Thermo's long winter hibernation. Having not eaten for months, polar bears naturally head for the outskirts of town, where it is easy to overturn garbage cans and gorge themselves until daybreak. But Thermo decided to wait until the townsfolk had finished their dinners because that's when the really good stuff was thrown out.

He peeked in the window of the first house he came to. The large family inside had not even started their meal. They were all sitting there watching television. Thermo knew all about television because as a cub he had been ear-tagged, radio-collared, and dye-marked by three different TV nature shows. These people had a large TV, and he could plainly see what they were watching.

Though famished, what he saw on the screen made him lose his appetite. There, on the National Educational Television Network, for every Eskimo with a TV set to see, were his parents—mating.

To make matters worse, someone with a British accent

was describing what they were doing. It was not a pretty sight. The rhythmic bouncing of the radio transmitters around his father's neck seemed to amuse those "blubber sucking, igloo building, seal killers."

Alone now, desolate and ashamed, Thermo just wanted to lose himself in the crowd. But, if you're a polar bear, there is no crowd.

※

HALF WIT

HOUSE

✳

The sign over the door of Half Wit House was reassuring. "Gibberish Spoken Here" meant that Irving Gluck could relax. He was still in shock at the way his last few seminars had been brought to an abrupt stop by outside agitators.

For some reason they were shouting, "Define your terms! Define your terms!"

What could be ticking in their sick little minds? Disrupting and short circuiting his thoughts like that was criminal. Especially when he was on a roll.

Gluck felt confident that the death threats he had sent himself in the mail should be ignored. He would not be silenced. The bomb threat that he had phoned in to Half Wit House if he were allowed to speak, could not be carried out if the proper security measures were taken.

If he wilted now, in the face of personal danger, it would somehow betray the memory of when he kidnapped himself and refused to pay the ransom, no matter what the personal consequences might be.

He felt he had grown from a life and death experience like that.

Fortunately, he had released himself unharmed.

But now his responsibility as an educator, role model, and leader was the important thing. After all, the house was sold out.

Gluck was halfway through his lecture on why he would "Rather be a fly on the wall than a hornet on a pest strip," when he paused.

He was starting to get on his own nerves and asked the security guards to remove him so that he could continue the meeting in an orderly fashion.

※

HIRAM

TYLER

❄

G od has chosen to speak to you through me," the
Reverend Hiram Tyler said to the young milk-
maid, "and he wants you to give me a blow job."

Reverend Tyler felt like a hypocrite. God had not spoken
through him in over a week. What's more, he was sure God
didn't want her to give him a blow job. But he would worry
about that later.

In his humble church Reverend Tyler pondered the con-
tent of next week's sermon. The subject, as usual, was to be
greed, envy, lust, gluttony, sloth, jealousy, and anger. His
flock had grown steadily during this series of sermons on
"The Seven Deadly Sins."

The sermons were liberally sprinkled with graphic
descriptions of his personal experiences while researching
each and every one of them. He had actually had a "near
death" experience on one occasion. He was researching "lust"
when he encountered "jealousy" and "anger" when Mabel
Swagger's husband unexpectedly showed up in the middle of
the afternoon.

He was released from intensive care after being on life

support systems for three months. His congregation thought it would be safer for Tyler to spend some time in a rest home in New Orleans until tempers kind of cooled down. It was there that he inadvertently discovered a previously unknown "Eighth Deadly Sin." It was sure to rock the theological establishment to its very foundation.

Reverend Tyler would only reveal that the eighth sin involved a bottle of champagne, a piece of silk, and a donkey. He would say no more for fear of leading poor weak sinners astray.

The subject of his next Sunday's sermon, "Whether man be angel or devil, a little pussy is absolutely necessary," is sure to be well attended.

※

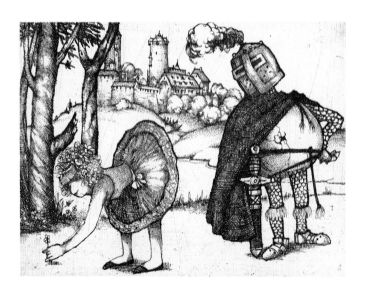

BAMBI'S

UNCLE

Bambi's Uncle Gus had outlived every stag in the forest. As a clever young buck he noticed that the little white spots on baby fawns' backs made them so adorable that even hunters could not bring themselves to shoot them.

So every year, just before the hunting season began, he would stand under a robin's nest until he had just the proper markings.

Uncle Gus would then venture out into the forest in perfect safety, secure in his adorable cuteness.

THAT

MAGIC MOMENT

✳

The night we almost met is etched vividly in my memory. There, across the crowded auditorium she sat, the most gorgeous woman I had ever seen.

Somehow, at a distance and among that vast audience, she seemed to glow with an aura that I had never seen before. I watched her as she took notes on the evening's featured speaker, Ralph Nader.

Mr. Nader began his lecture on the night's theme, "Lessons from the past, lest we forget."

"Pompeii, Italy, a resort town built at the foot of an active volcano is simply the worst example of city planning I have ever seen," Nader began with all the sincerity he could subpoena to his lips. "Even if Mt. Vesuvius had not erupted in the year 24 BC, and killed every living thing there, the traffic and poor air quality would have made life there unbearable anyway."

That was interesting. But I was so thunderstruck by the luminous beauty of the woman across the way that I could barely concentrate on Nader's lecture.

"Venice, Italy is another prime example," Nader continued, as he changed slides. "Ignore the surface beauty of the place and imagine the centuries of muck and slime that ebb and flow beneath it. The canals are still not filtered, half the population under twelve can't swim, it's sinking into the Adriatic Sea, and it smells to high heaven. The city of Venice is the kind of ill-concieved mistake we must never ever allow to happen again."

I was surprised to hear that. Romantic Venice was always my favorite city.

I listened to Nader but I could not take my eyes off that exquisite woman. I somehow found the courage to leave my place at the rear of the auditorium and move closer to her. I worked my way to a seat directly behind her. She turned a bit my way. I thought, "Hmm... lovely profile. No Brooke Shields though... Nose a bit long, and well, just a little different. Yes, but she *is* beautiful nonetheless."

Mr. Nader clicked to a slide of the magnificent statue of the Venus de Milo. "How could the authorities permit shoddy workmanship like this?" he asked. "When those arms fell off that statue, they could have injured an innocent passerby." He was on a roll. "And, if you think getting hit by an arm falling from a beautiful marble statue hurts, how would you like *this* to fall on you?" he asked, as he slammed a fist on the lectern and flashed to a slide of the Leaning Tower of Pisa.

From my new vantage point, her ears were completely blocking the screen. So I just sat there and looked at the nape of her lovely neck, and listened to Ralph Nader go on and on

about the Leaning Tower of Pisa. Actually, I had always planned to visit Pisa, now I think I'll skip it. It sounds too dangerous.

Nader moved on to his next horrible example, "As you can see by this slide of the ancient pyramids of Egypt, the absence of clearly marked exits or entrances made the Egyptian pyramids little more than deathtraps."

That's true. I had never thought of that. I decided never to go in one of them again.

Wow, I've never seen that much hair on a woman's neck before in my life.

"And just look at these paintings by Rembrandt van Rijn!" Mr. Nader shouted.

I *love* Rembrandt but I was distracted. The hair on her neck looked like it might be growing all the way down her back! Did Nader say he was going to talk about Rembrandt? Yes! Good. I considered him the greatest painter who ever lived.

Nader showed a series of close-ups of Rembrandt's most magnificent masterpieces and then commented that, "Only Rembrandt's sloppy, inept, and indifferent workmanship can account for the cracking and chipping of canvas after canvas of his."

Gee, look at that. The paintings *are* all chipped and cracked.

What *was* that smell? It was emanating from that woman sitting directly in front of me, blocking my view? I couldn't tell if it was cologne or lacquer thinner! And, God, her posture!

At the end of his initial presentation, Mr. Ralph Nader promised his very attentive audience that, "After the intermission, I will completely expose the shameless French Impressionist rip-off."

Even though I *love* French Impressionist paintings more than any others, I didn't return to the lecture hall after intermission. Encountering the girl of my dreams was one thing, but not being able to stand the sight of her after 20 minutes was going to be tough for me to deal with.

ECONOMICS 101

※

I'm no economist so this is probably a foolish question: who paid for the Vietnam War? It cost $589,000,000,000. That's 589 _billion dollars_. Yet not one cent in taxes was ever raised to pay for it. Remember? They said the "Great Society" could afford "guns _and_ butter." Well, sure. What they really meant was, "If we _need_ more money we will _print_ more money." How simple. It wasn't long before our presses began humming along twenty-four hours a day doing just that. Printing more money. Perfect! Maybe no one will notice. The rest of the world was going to pay for our war and it wouldn't cost _us_ anything! Unfortunately, if I remember correctly, England, France, Germany or Japan—I know it was one of those ingrates—caught on. They started dumping and discounting and showing no respect for our Yankee dollar. Once they started it, every other country did the same thing. The whole international economic world balance changed. Our national deficit is now almost five trillion dollars. That's $5,000,000,000,000.

Everyone pretends we will pay it someday. Everyone knows we will _never_ pay it. Because everyone knows it _can't_ be paid.

As I said I'm no economist. But is it possible that the answer to the question of who paid for the Vietnam War (which ended twenty years ago) is—we are—now, still, and probably forever.

That "cowards die a
thousand times before their
death," certainly came as bad
news to Andy Mumphrey.

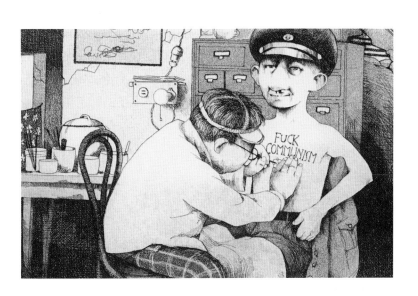

THE WISDOM
OF GDINSK

※

The people of the great nation of Gdinsk had suf-
fered great casualties in the surprise attack and
were frantically trying to beat their plowshares back into
swords. Dueling and fighting with plowshares had proved
ineffective.

But somehow their incredible bravery miraculously pre-
vailed over the well-armed invaders.

Their glorious victory had taught them a valuable lesson.
They would never again be caught unprepared. In time, they
succeeded in beating *all* their plowshares back into swords.
This, of course, made plowing much more difficult. The

comforting sense of security felt by the people of Gdinsk was not diminished one whit by the years of crop failures that followed. It wasn't long before their once fertile farms became fallow, dusty wastelands.

Eventually, the swords used to plow the desolate land were abandoned everywhere. Though they were now hungry and malnourished, every man, woman, and child in Gdinsk was well-armed.

Bleak harvests and continuing cycles of drought plunged Gdinsk deeper and deeper into famine and plague. Desperate conditions eventually led to violent clashes—village against village, brother against brother. The civil war that followed was one of the most brutal ever waged.

After a decade of starvation and fratricide, the survivors were so weak that they barely noticed, nor really cared, when the foreign army occupied their country without resistance.

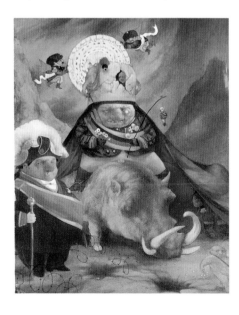

COLONEL

COBB

✳

My great grandfather Colonel Homer Cobb beat Mark Twain to South America in 1867. They both had heard about a leaf that the natives there chewed ,which enabled them to work like mules for twenty hours a day. They never tired, they never got hungry, and they never complained about anything. When they had a rare day off they held festivals and dressed up as colorful farm animals. They sang and danced to happy music until it was time to go back to work. They were able to do this because they chewed that magical leaf.

The end of slavery in the United States meant that labor in the South would soon become altogether too expensive. The man who brought that leaf to the newly slave-free states would become wealthy beyond imagination. The pious Colonel Homer Cobb believed that the Merciful Lord had once again looked down upon his former slave masters, saw their plight, and in his boundless mercy and infinite wisdom provided a blessed replacement for their recently freed and ungrateful Africans.

A report of the discovery of yellow gold in the Yukon

distracted Twain to the north, leaving the green gold of the Yucatan peninsula to Colonel Cobb.

Old Cobb followed the Greek philosopher who advised, "Establish an independent income and *then* practice virtue." Socrates would have been proud of him because the cocaine he shipped back to the United States and sold for $1 an ounce everywhere in America cost him about two cents a ton. It was legal and it was *everywhere*. Grocery stores, barber shops, *everywhere*. Why, some fellow in Cleveland even put it in soda water with caramel coloring and sold it as a drink.

Cobb now considered himself to be in the pharmaceutical and health care racket. When he got back to New Orleans he exchanged his pesos for dollars and looked around for other medicinal opportunities.

He backed Dr. Bascomb Q. Acker, an inept veterinarian he had met in a brothel in Baltimore during the Civil War, in a line of patent medicines. Their "Autumn Leaf Extract for Women" was two parts water, one part kerosene, four parts gin, and a dollop of cocaine. It changed the southern lifestyle for quite some time. It sold for $4 a bottle and they couldn't brew it fast enough. Then they came up with "Crossman's Specific," "Liquid Opeldoc," "St. James Oil," and "Nez Perce Catarrh Snuff." They were all pretty much the same brew with a switch to rye or bourbon here and there, now and then, depending on Dr. Acker's diagnosis of the illness market at that particular time.

In 1896, Cobb, recognizing a need caused by a new scientific breakthrough, marketed a line of X-ray proof under-

wear for the ladies. They would, as his handbills claimed, prevent the "exposure of your private regions in public places." It was very successful.

None of it was as profitable as politics in Lousisana. A state where you sealed a deal with a handshake. And you were bound to it for the duration of the handshake. He bought his way into the state legislature, Speaker of the House as a matter of fact. Six consecutive terms. When he died in 1948 at the age of 106, *The Times Picayune* wrote that the state had lost its "Great Obfuscator." He would have liked that. The Colonel left his vast fortune to the "Cobb Business Ethics Scholarship Fund" at Tulane University. On his headstone is etched a credo that has made many a young idealist proud to be American. It reads:

Be not afraid to walk a mile
in another man's shoes, brother.
For then you're a mile away,
he's barefoot, and you've got his shoes.

❋

Yippie

Yuppie

HO NAH WATO

＊

When Ho Nah Wato strayed from his war party, he came across a still forest pond.

As he was drinking, he saw his own reflection on the water. He had never seen anything so hostile and ugly. Being a fierce warrior, he drew his bow and shot many arrows into the monster until it disappeared.

But soon his enemy reappeared.

Ho Nah Wato was not afraid. He had mastered and perfected all his tribe's war skills, and he had many victories, so brave was he. He flew to the attack with his spear and tomahawk, which had always served him so well.

He could hardly believe his foe could survive his attacks and return again and again.

Every encounter increased the hatred Ho Nah Wato felt for his mortal enemy. "Unto death will I battle this warlike beast who would destroy my people."

After many and many a battle, the weary Ho Nah Wato realized he must think of the future.

"Come son, behold our mortal enemy. If I should perish you must pledge to protect our people from this cruel villain."

That was many many moons ago. Ho Nah Wato's son

never wavered from that pledge. Yes, his son, and his son's son and his son's son's son, generation after generation, attacked their enemy whenever he reappeared.

What greater heritage, what nobler mission than to devote your life to protecting your people from harm?

And to this day, if you know the way, deep in the forest, you will find the gallant battle raging still, as it always will—so long as the legacy of Ho Nah Wato prevails.

THIS LOOKS
LIKE WAR

❋

Man is called a reasoning animal because he will come up with a reason for doing whatever it is he wants to do.

Take the accidental bombing of Switzerland by American warplanes in the spring of 1997. There had been a mix-up with the computer controls for a squadron of B-52s, and unfortunately they bombed several ski resorts mistakenly identified as terrorist missile sites. Naturally, the Swiss Air Force responded, and there were pitched battles for some time. During a lull in the fighting, everyone stepped back and tried to sort the whole thing out.

The government's most able spokespeople, trying for damage control, descended on all the radio and TV talk shows. They claimed that our radar screens had indicated the Swiss were attacking, not skiing.

After three days, a Gallup Poll showed that 52% of Americans regretted the bombing, but thought that as long as it had started, we should go in and finish the job. 26% felt the attack was long overdue, and a sizable minority thought that Switzerland had been asking for it for a long time—ever since their last war in 1642.

The President's popularity went right through the roof.

The Pentagon spin doctors were very effective in obscuring their stupid blunder. Within two days there was a yellow ribbon tied to almost every tree in America. They came up with ambiguous sound bites that kept the Op Ed page columnists busy with pro and con opinion babble for weeks. Charles Krauthammer of *The New York Times* wrote, "While some may sympathize for the tragic loss of lives, the Swiss are fooling no one. It's the oldest trick in the book... put on your 'Peace Face,' wait for two or three centuries, and then STRIKE!"

George Will, with his usual laserlike sense of history, cut through much of the rhetoric when he wrote that: "...the bombing that devastated Switzerland this past week was a mistake, but it should not make Americans forget that Switzerland, unlike Canada, was neutral to Hitler during World War II. Switzerland is now and always has been a closed society. Who runs that country? Nobody knows. What are they trying to hide? Some people have called Switzerland a peaceful country. Well these people should know that the Swiss have had a military draft for the last 200 years. Why? And for what purpose? That is the question Americans should be asking themselves today, rather than crying over spilt milk."

Henry Kissinger had this perspective: "The Sviss obwiously have alvays had uh segret agenda. Today dah Alps, tomorrow dah verld! Dis vas dah right var at dah right time! If they had not been stopped dah entire global balance

vould have been thrown into disarray. Vomen can't vote dere you know."

"Name ONE Swiss Freedom Fighter!" demanded Mike Royko of *The Chicago Tribune*, "Name one Swiss ANYTHING!"

He continued, "Today Switzerland is a sanctuary for ex-Nazis, South American dictators, S & L directors, and several of my ex-wives."

"Maybe if we dropped The Big One on Geneva," suggested Colonel Oliver North to Rush Limbaugh and his twelve million radio listeners, "They would listen to reason."

"And we might kill a bunch of Swiss liberals," added military expert Major General Limbaugh.

Said Jeanne Kirkpatrick on *Crossfire,* in her smug and arrogant manner, "They are the most smug and arrogant people on earth. The Swiss people have always looked down on everyone."

"That's probably because of the Alps," observed the insightful John Sununu.

"Oh puleeeze...? ...! ...?!?" countered Mike Kinsley with his usual eloquence.

In the end, it all turned out to be a relatively forgettable international incident. After paying substantial reparations and handing out medals for bravery and a job well done, the Swiss-American Peace Treaty was signed in Sarajevo, Bosnia, in 1998.

THE FIRST
INSTALLMENT

✳

What really bothers me, Edith, is that someone's mind could be so warped as to go to all the trouble of doctoring these photographs to make it appear I had done something you wouldn't approve of. And then mailing them to you. God, what a sick sense of humor. It must be someone who is not only out to get me, but pretends to keep track of my movements. I don't think that's funny. Look, Edith, how a room at Caesar's Palace has been superimposed behind that picture of my face at Mark's bar mitzvah? You can tell because that's when you were in traction and I had that great tan, remember? Isn't it amazing how they can take a man's face and put it on another man's naked body like that? I'll tell you one thing... ha, ha... and I'll bet you'll agree, you little dickens, both of us wish that *was* my body. Whoa, that guy must have really been turned on. Ha! Now, that's amazing. I just can't figure out how they added those three nude girls in the photos, can you?... (yawn)... I know what you're thinking, sweetheart... "Let's get some sleep and not make a big deal over a stupid practical joke." Right dear?... Right!... Gunnight, sweetheart...

✳

OTTO

✻

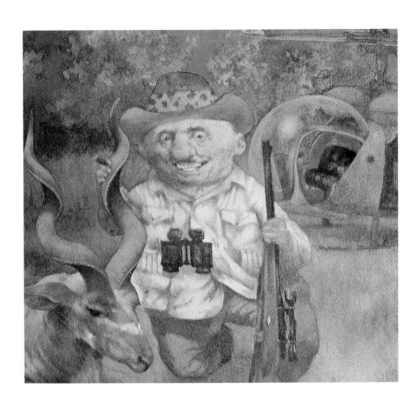

O tto Gbolt was in a philosophic bind: Adolph
Hitler had given anti-semitism a bad name.
This was a very emotional issue for him because he had lost
close family in the Holocaust. His uncle was a guard at

Auschwitz. He was beaten to death by the inmates after the armistice, for some reason.

Because of this, there was no denying that Gbolt wasn't crazy about Jews in general and Israelis in particular. Oddly enough he was an ardent Zionist because if their goals were met there wouldn't be any more of them in the United States, which would have made Otto very happy. The "Philistines" of the world were not his problem. It was the *"Phil Epsteins"* of the world that had caused him grief. And if he read his history correctly, Voltaire, Shakespeare and T. S. Eliot had had their problems with the same guy.

Tattooed on the knuckles of Gbolts left hand was the word HATE, and tattooed on the knuckles of his right hand was also the word HATE.

His shrewd investments in Livestock Futures (he knew that livestock had no futures) was the foundation of his fortune.

A nature lover, his belief that "Little birds that will not sing must be *made* to sing" was not merely sophomoric idealism. He backed it up with a $5 million research grant to Bob Jones University. He was active in the "Save the Seals" movement. He knew that if you saved 14 of them, you'd have enough for a bedspread. Like many of his kind Otto fantasized about having the thrill of actually killing the last living example of an endangered species.

An enormously successful chain of franchised schnitzel restaurants, "Two Guys from Buchenwald" had made him one of the wealthiest men in the Cincinnati area.

A grateful Otto Gbolt wanted to give something back. He pledged to use his fortune for good works.

His three-hour feature film "Holocaust II" revolted the critics but struck a responsive chord in enough people to make it a box office hit.

The pictures in *Hustler* magazine of him in Israel pulling up a tree was an unexpected public relations bonanza.

A gifted speaker, Gbolt's "If the Good Lord had wanted everyone to be equal he would have made everybody white" and his "As far as I'm concerned there is only *one* race... The Belmont Stakes!" are not only in *Bartlett's Familiar Quotations* but have been used in debates at Harvard and Oxford.

The nationwide exposure he got as the force behind the "Death Penalty for Attempted Suicide" movement led to a personality profile on *60 Minutes*.

Though heavily edited ("Well hung is well done," "The meek shall inherit Jack Shit") he was pleased. Especially when Morley Safer ended the segment saying, "Whatever your opinion of Otto Gbolt, he is truly one of a kind. The last of a vanishing breed."

※

SWAMP KNOB
From town into city

E lection Day was a week away in Swamp Knob,
West Virginia.

Mayor Stanislaus "You can call me Stan" Starski was
confident that he would be reelected based on his record of
achievements during three consecutive terms in office.

For one thing, employment was up. This was due main-
ly to the maximum security prison Starski had built next to
an all-girl high school in the middle of Swamp Knob's best
residential neighborhood.

Because of the poor construction of the prison, the
turnover of guards and prisoners was quite impressive.
Between massive jail breaks, his nephew's construction firm,
which had built the prison, was investigated by an impartial
panel. The Starski Commission of Standards and Practices
found no improprieties whatsoever. They concluded that it
was neither inferior building materials nor incompetent con-
struction that had caused the problems. It was, most likely
,the very strong plastic spoons used in the mess hall that
enabled the desperate convicts to tunnel through the five-
foot-thick walls in fifteen minutes.

Mayor Starski's opponent for the office of mayor, Thadeus

"Thad" Wilfong, was not called the "Peckerwood Phrasemaker" for nothing. His catchy campaign slogan—"The prison is his'n. The future is our'n!"—had struck a receptive nerve with an electorate that appreciated a well-turned non sequitur. Wilfong had profound insight on the city's welfare payments to the poor and homeless. "A beggar, once mounted, will ride his horse to death!" He declared: "Stop giving them money. Buy them a horse. At least when it dies they'll be in another town." Wilfong stood a very good chance of unseating Mayor Starski.

Selective enforcement of the law brought crime statistics down during Mayor Starski's term. Muggings and assaults were off more than 50% since the prison was completed. Some say that was because, after it was built, no one would come out of their house after dark. Starski claimed it was because all the crooks in Swamp Knob were in the jail.

Starski had also seen to it that environmental standards in Swamp Knob were virtually nonexistent. Since the strip mining companies had mined all the coal, the town's main source of income was a raw toxic waste dump next to the school playground. It had been approved unanimously by his city council, all of whom lived elsewhere.

The Swamp Knob Chamber of Commerce hated to see industries leave the county and lobbied very hard to keep them there. They were successful in securing the R.J. Reynolds Company's Red Man Sports Tobacco division—"The Official Chaw of the Olympics." Starski also bought a zoning variance for the Armour Meat Packing Company. Their main slaughterhouse was now flourishing on Riverside Drive.

The Chamber also hoped to offer broad enough tax incentives to lure the Manville Asbestos Manufacturing Company to start a plant there. It was a very close thing. The Island of Krakatoa was the only other location still in the running.

A masterful political fundraiser, Starski had perfected his "fixed grin," "courtesy laugh," and "have a nice day" looks. "You're outrageous!" he would bellow to the dullest, richest person in the room. "If I win, I'm gonna owe ya," he would say with a wink and the smile of a thousand teeth, "more than I can ever repay."

To make sure his name was always in the public consciousness, Mayor Starski had himself paged every fifteen minutes at Kmart.

As charming as he could be with the big money guys, behind closed doors with his staff he was a different guy.

"Why don't you grab that tiny brain of yours and try to squeeze an idea out of it? Use two hands, you know, like it was your dick!" he suggested at the top of his lungs to his campaign manager and second cousin, Orville Hubbard, when the polls indicated that the voters of Swamp Knob just might turn out in record numbers.

To gain a few votes he was not above raising divisive ethnic issues. "Except for Christopher Columbus, what did the Italians ever do to found this great nation?" he said in a speech to the Daughters of the American Revolution. (He had looked it up. There wasn't *one* Italian Founding Father). The DAR was very receptive to this point of view, but it caused a furor elsewhere. When he was found to be absolutely correct, his ratings

in the polls soared. He was also quite aware that there were only three Italians in Swamp Knob, and none of them were registered voters.

His most memorable paraphrase was spoken at a Teamsters Union meeting: "Ask not what your country can do for *you;* ask what *you* can do to keep Mexicans *out* of your country."

He was going to be very hard to beat.

❋

Elmo Jakes was a Type A personality, an emotional medical disorder characterized by excessive impatience and easily aroused hostility in trivial matters involving other people. He was the Chief of Police. He had originally come to Swamp Knob under the government's witness protection program. He needed work and took the first job that came up.

Chief Jakes had a staff that included Dixie Balldinger, his secretary-receptionist and two part-time reserve volunteers. The one jail cell at the station was usually kept ready for Chief Jakes' number one weakness—the afternoon nap— usually taken when his wife was out of town and with Dixie at his side. If cleavage was your thing, you would want to nap with Dixie. Cleavage was Chief Jakes' thing.

❋

Warren Dweck was "Harvard Business School 1987." He was an ambitious young business predator with the vacant look of a professional golfer. Tall, good looking and pale, except

for his corporate nose, which was browner than hot fudge. He had interned in business ethics with Ivan Boesky and came very close to doing ten-to-twenty in the center of Swamp Knob's newest building if you know what I mean. Fortunately for him, he had coerced a young office boy into signing all the official documents when he was working with Boesky. The office boy who signed the papers will be getting out of prison in about seven more years. Dweck wrote to him promising that there would be a job waiting for him when he got out. A smart executive can always find room for a good office boy.

Dweck was here in Swamp Knob looking for new locations.

Actually, he was searching for an Indian. *Any* Indian as long as he was an American Indian.

Warren Dweck had found a loophole in a treaty with the Indians of West Virginia dating back to 1781. Any American Indian could open a gambling casino on Indian land on the outskirts of town, and the federal government had no jurisdiction to interfere whatsoever. Steve Wynn, the owner of the Golden Nugget and Mirage Hotels in Las Vegas left Nevada long enough to learn a "rain dance," fly in and claim that— forget Uncas, Chingatchgook, and Daniel Day-Lewis—*he,* Steve Wynn, was the last of the Mohicans. He gave his word as a "noble red skin," as he put it, that construction on his new casino, Geronimo's Teepee, would begin immediately and would be bigger than Caesar's Palace and the MGM Grand combined. When it was discovered that the only tribe the Wynn family ever belonged to was the Ashkenasi Tribe of Warsaw, Poland, those plans were put on hold. So now it was

Warren Dweck's job to find an Indian, have him and Steve Wynn prick their fingers with a pin, rub them together, become blood brothers, and then "Let the games begin!" But it wasn't as easy as that. The last Indian had been run out of Swamp Knob in 1782.

※

Macho Gazpacho was the bouncer and bartender at the Predatorium, Swamp Knob's only singles bar. He had been a pretty good heavyweight boxer in the 70s. Whitey Bimstein, his trainer, had nothing but praise for Gazpacho, "Real game he was. Big heart. Big left hook. Not much else. Like a turnip. You beat on it and beat on it. It may change shape but it don't bleed. That was him too. He was a clean living 'born aginner' ya know. Always quoting 'the book.' I remember when he won the WBZ Super Middle Cruiserweight Championship of South West Virginia from Rocky Nelson. Fourteen rounds. A real war. He said, 'I couldn't have won the title without the help of Almighty God. I dedicate this knockout victory to the glory of my merciful Lord and Savior, Jesus Christ.' I hated to be the one to tell him—he was so happy. But I had to give him the bad news. 'Champ,' I said, 'Rocky Nelson just lapsed into a coma. He's on life support systems.' He said, 'Oh God! I'll pray for him.' I said that maybe praying for him wouldn't be such a good idea. He wanted to know why. I said, 'You already got what you prayed for once tonight. To beat him to a pulp. Maybe you should just settle for that.'

"Macho didn't have many big paydays in the ring. And

let's face it, he wasn't going to win any chess tournaments. So here he was making a living fighting drunks in a country western dance hall. He was happy though. At least he still got to hit people. That was the main thing.

＊

Wiley Boggs was the town's atheist and village square philosopher. Most parents in Swamp Knob considered him a bad influence and many forbade their children to listen to his lectures and theorizings in the park. But when kids see a man with red hair, black moustache and white beard, one brown eye and one blue eye, standing on a bench shouting at the top of his lungs, they get curious. All Wiley needed was one listener and off he went. Sometimes for an hour or more.

When he was a young man Boggs tried to enlist in the Army but was turned down because of a perforated eardrum. Whatever caused it had also passed through his brain. The Army termed this "collateral damage" and it didn't count, so Wiley was drafted a short time later. In 1967 he was accused of retardation when he refused to shoot Vietnamese peasants and was given an "undesirable discharge."

Devastated, without direction or purpose, Wiley Boggs roamed the world seeking spiritual enlightenment. He found it to some extent. He had swum the Hellesponte. He was baptized in the waters of the Jordan. He had bathed in the holy waters of the Ganges. All that was many years ago but the rash on his genitals is with him to this day.

Eventually Boggs tired of horizons and space and dis-

tance and things like that. He now wanted to deal with what he termed the "genuine fungus of life." So here he was, back to his roots in his own home town. Swamp Knob, West Virginia.

To some extent his confidence returned. Before long he regained his spiritual center. Boggs knew the Bible... sort of. He knew the Koran... sort of. He knew the Baghavad Gita... that's right, sort of. He was not what you would call a cover-to-cover reader. More of a *Bartlett's Familiar Quotations* man. You know, three lines and turn the page. A compulsion to preach coupled with a faulty memory is not a combination that results in clarity. Boggs tangled so many sources in his sermons that his mixture of the Bible, the Koran, Shakespeare, Grimm's Fairy Tales, Aesop's Fables, the Communist Manifesto, and everything else almost amounted to "speaking in tongues." Quotes, misquotes, and near quotes. And the fact that he changed his religion and politics on the average of every three days made every Boggs sermon an adventure.

CBS's *On the Road with Charles Kuralt* heard about this eccentric small town philosopher who preached gentle folk wisdom in the town square, and sent their mobile unit to Swamp Knob.

Boggs was standing on a park bench speaking to the crowd—two third graders and a man obviously in a twelve-step program.

He began, "Citizens! I insist you listen to this. To persist in dismissing the Epistles of the Apostles is impossible and impermissible." Charles Kuralt was cocking his head first this

way, then that, like a collie trying to understand what was being said to him. Boggs continued: "Popular ignorance, maintained by craft and deceit, generates folly, which frustrates wisdom, and deprives merit of its crown, until reason and patience at last overcome deceit by revealing truth. Or there ain't a Chang in China!" Kuralt got in his Winnebago and drove off.

There are defining moments in the history of every town. For Swamp Knob it was that election week in November of that year.

First of all, Warren "Harvard '87" Dweck, in a plea bargain that added three years to his former office boy's sentence, arranged for Russell Means, the imprisoned Indian activist of Wounded Knee fame, to be transferred from Leavenworth to the prison in Swamp Knob. He was now a very official American Indian resident. After a visiting hours pow-wow, Means agreed to make Steve Wynn a blood brother for 2% of the gross of the yet to be built Geronimo's Teepee Casino and Spa. Wynn thought that for 2% of the gross, pricking fingers for a little drop of blood was a bit much. He threw in complimentary limo service and Means agreed to a complete transfusion.

Charles Kuralt stopped at the Predatorium on his way out of town to use the john, struck up a conversation with Macho Gazpacho at the urinal, liked what he saw, and did a story on him for CBS. The public, for reasons known only to the gods of television, loved him as much, if not more than, Richard Simmons. He quit his job, made a fitness video, *Sweatin' with the Imbos,* and is thinking of returning to the ring.

People magazine was doing one of its in-depth biographies of Police Chief Elmo Jakes, the only police officer to appear on TV's *America's Most Wanted* as a police chief one week, and a wanted fugitive the following week.

Hollywood discovered the town. Robert Redford plans to film a sequel to *A River Runs Through It* in Swamp Knob. Tom Cruise and Julia Roberts will co-star. Its theme concerns the growth of a small town into a big city. It will be titled *A Sewer Oozes from It.*

The mayoral election turned out as all the pundits predicted—crooked to the core. The debate between the candidates at All Saints Church degenerated into a near riot when, during general questioning, Dixie Balldinger asked what city hall's policy was for maternal leaves for city employees who became pregnant on the job. Several male members of the city council appeared to have come down with a sudden virus or something. Two of them lurched out of the hall and could be heard retching in the alley behind the church. Mayor "Stan" Starski passed out altogether and candidate Thadeus "Thad" Wilfong came to the microphone and denied that he had "ever even laid eyes on the woman much less fuc..." He thought he had caught himself in time—but when he felt the impact of Bertha, *Mrs.* Thadeus Wilfong's seemingly brick-laden purse alongside his head, it seemed perhaps he didn't. In a panic, Wilfong picked up the huge Bible on the lectern and held it over his head, for protection from Bertha's fury. She kneed him in the gilloolies to bring his guard down and continued to pummel him until he fell off the stage and into a pile of "Re-Elect Starski" posters.

The pictures on the front page of the *Swamp Knob Intelligencer* of Dixie Balldinger trying to revive Mayor Starski with mouth-to-mouth resuscitation were bad enough, but the caption, "Sex Scandal—As Close as City Hall?" must have jogged some "recovered memories" (Geraldo's subject on his TV show that day), because both candidates were accused of child molestation by Ophelia Otis Guttman, an eighty-eight-year-old widow. She said that after watching the psychiatrists on *Geraldo,* she suddenly remembered that she was molested when she was six months old. Both Starski and Wilfong are in their mid 50s but are in jail awaiting trial without bail nevertheless.

Democracy has often been called the great equalizer. On this particular election Tuesday it turned out to be true, but with a slight twist. Wiley Boggs, penniless park preacher and "Sage of Swamp Knob," somehow, over the years, must have touched the hearts of enough people to become the mayor-elect as a write-in candidate.

After the swearing in ceremonies, Mayor Boggs turned to the crowd and spoke reverently of the Supreme Creator in his inauguration prayer: "I find him in the shining of the stars, the ocean's tides and the vast beauty of the sky. I love him for his sunset and the rainbow's hues. I mark him in the flowering of the fields. But in the ways of the people of Swamp Knob I find him not."

It is possible that Mayor Wiley Boggs was a "stealth candidate" for the Christian Right?

I SHOP, THEREFORE I AM.

HERITAGE

✳

The city of Las Vegas had every reason to feel proud. Their Museum of Natural History had grown to be a treasure trove of the city's cultural heritage.

On permanent exhibit were the first ballpene hammer used in collecting unpaid bets, as well as the first two kneecaps it was used on. They were kept in reliquaries next to a display of counterfeit chips, along with the bodies of the actual corresponding counterfeiters.

The vast main gallery had a spectacular exhibit of the uniforms of the entire 1919 Black Sox baseball team.

The shirt Bugsy Siegel was wearing his last day was across from a forty-foot-long gallery of framed Pete Rose IOUs.

Meyer Lansky's foreskin had been removed to make room for the sweat socks that Tom Jones has in his jock when he performs.

The photo gallery featured a picture of Wayne Newton's heart magnified 100 times, making it very close in size to a normal one.

A vial of Don Rickles' sweat, and a tape of the only laugh Marty Allen got in his 312 appearances at the Riviera were rare as well as popular displays.

The expert staff members were carefully restoring the original pasties that Lili St. Cyr wore at the Desert Inn in the 50s. They had been bought at auction from a private collector who had not properly cared for them.

A life-size replica of Dean Martin's liver dominated the courtyard across from the tomb of the Unknown Welcher.

LeRoy Nieman's mural of Tony Orlando had just been retouched to remove Dawn.

Las Vegas' first hooker had graciously willed her vagina, and replicas of it sold well in the gift shop.

Frank Sinatra's wigs were arranged in chronological order.

LaToya Jackson's "sincerity" display was on temporary loan for exhibit in the Cathedral of St. Vigorish in Reno.

Father Savonarola bet at least 8 to 5 that it would increase attendance at this Sunday's services.

The Las Vegas Story

FASHION NOTES

*

History's Worst Dressed Army

The British Continental Army. In 200 years not *one* suc-
cessful ambush. And this in the forest, which is the
very best place *for* an ambush.

LOVE IT OR
LEAVE IT

In the 1960s, Arnold Benedict seemed to be on a collision course with the Bill of Rights. While exercising his "Freedom of Assembly," he was arrested for loitering.

"Freedom of Speech" evidently did not include telling the judge to go fuck himself, because then they booked him for obscenity too.

"Freedom of Expression" was in full effect—except for the length of his hair. He had been thrown out of school in 1968 because of it.

"Life." He got drafted into the Army.

"Liberty." He was sent to prison for avoiding being drafted into the Army.

Arnold has begun his "Pursuit of Happiness" now that he has managed to survive all his other freedoms.

Every man marches to a different drumstick

FERLMANN

Being fabulously rich made it difficult for August Ferlmann the 3rd to realize he was merely a fabulously wealthy bore. Yet he felt good about himself. He was skilled at telling golf jokes to the same people he had heard them from the day before. He knew his timing must have been perfect. Why else would they laugh uncontrollably only a day after they had told the same joke to him? It *must* have

been his instinctive comedic timing. That probably explained the special kinship he felt for the long departed but still beloved Jack Benny.

It's safe to say that his after-dinner anecdotes were his specialty. Not everyone can fly thirty-two guests to Paris on the Concorde, all expenses paid, for a late supper at Le Tour D'Argent as August did. Then tell pointless and interminable stories, and have not one guest mention to him that he had droned out the exact same pointless and interminable stories the last time he flew them in.

His wife seemed so entranced by his stories that she seemed almost to be in a state of sleep, deeper and deeper at each event. One time it was so deep, she was dead.

Lady Abigail Astor Marlborough Ferlmann left not one red farthing to August in her will.

Though now penniless, August is doing well, judging from his letters. We'd love to see him, but it's a grueling twenty-minute drive to the mobile home park in the San Fernando Valley where he lives.

※

SCHADENFREUD

❄

I have long suffered from a severe case of Schadenfreud—a delight in others' misfortunes. Not the loss of a limb or anything serious like that, but little every day misfortunes. Like someone losing his life savings trying to get an extra $\frac{1}{2}\%$ interest in an uninsured bank account. A politician getting a brain cramp in the middle of a televised debate. Or Reverend Schuyler getting busted in a porn shop. A Rolls Royce out of gas on the side of the road. Ross Perot going bankrupt. A TV newsclip catching a neighbor with a hooker. Stories of lottery winners whose lives were ruined by the money. An ideal couple I've always envied slugging it out in a nasty vicious divorce.

I'd like to write more, but... ouch... dammit! I just broke a fingernail on this frigging typewriter!

❄

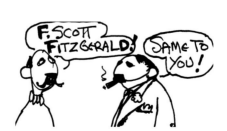

190

H A !

✳

I joined in the standing ovation. I was applauding, but I was a little misty too.

Don Rickles had just told the audience at Ceasar's Palace that he never picked on a "little guy" and how he loved the Almighty God as much as he loved his agent, Joe Scandori.

This meant more to me than to the others. After all, I was the one that he had gotten up on stage and belittled and humiliated. He had his problems with me. His humor seemed strained. He seemed to be reaching and just couldn't come up with anything that I thought was funny even though the audience was hysterical.

I was surprised because I had seen Rickles make fun of boogies and chinks many times. And that thing he does where he makes them all do those Indian war whoops makes me laugh till my sides ache.

At last night's show he was absolutely a scream when he got a couple of beaners up there and made them act like farm animals.

And he said he never picked on a "little guy."

Is he great or what?

✳

BISON

❋

In 1850 there were 41,000,000 buffalo in the United States, with a population of 8,000,000 people.

A mere ten years later, there were only twenty-seven buffalo and 12,000,000 people.

In 1994 there were 1,000,000 buffalo and 280,000,000 people.

This is very significant, but of what, I haven't the vaguest idea.

❋

Brigham Boone had hooked his wagon to another wagon

Erving Glick, inventor of the
Mood Swing.

❋

" QUOTATIONS "

"Break a leg."
—Torquemada, on opening
night of the Inquisition, 1474

"Come back little Sheba."
—King Herod, 19 BC

"The play's the thing."
—Tinkers to Evers to Chance

"I am not a crook."
—Mother Theresa, 1984

*"If there were no God it would
be necessary to invent one."*
—Thomas Edison, 1927

"Here I stand, I can do no other."
—Frosty the Snowman

"Soak the rich!"
—Vito Jacuzzi, 1956

"No man is an island."
— Orson Welles

"No man is an island."
— Irving Alcatraz

"Living well is the best revenge."
— Mother Theresa

QUOTES NO ONE HAS EVER HEARD

"You know, you're right! I've changed my mind."
— William F. Buckley

"What!? And ruin my image?"
— Madonna

"Lump it!"
— God

"I'm bored."
— Leonardo da Vinci

"I am a crook."
— Richard M. Nixon

"I will do <u>anything</u> if there's money in it."
—Charles Bragg

"WOW! I never thought of that."
—Leonardo da Vinci

"Now that I think about it, I was wrong."
—H. Ross Perot

"Forgive and forget.
—Simon Weisenthal

"I hope I'm not boring you."
—Hugh Downs

"If I was insensitive to your feelings, I'll never forgive myself."
—Howard Stern

LIFE

STUDIES

✻

I've spent some time now working for my doctorate in life studies. It's a study of the various attitudes on the sanctity of life held by people with differing beliefs. I began the project researching various groups that have a strong tradition of reverence for life: Quakers, Seventh-Day Adventists, Jehovah's Witnesses, and some other strange sects who opposed the slaughter of the people of other countries even when it was popular national policy.

Then I stayed up with an anti-capital punishment group keeping an all-night vigil outside Attica Prison to protest the execution of Hannibal Lecter's twin brother. You know him, the one that went bad. Then I infiltrated a Pro-Life Death Squad and got some very unusual insights concerning their pro-life bombings of abortion clinics and pro-life murders of abortion doctors.

I ignored national borders in my study. For example, in India the life expectancy of a cow is eighty-seven years; of a person, thirty -years. And the Jains of India sweep brooms in front of them when they walk lest they step on an insect and kill it. They also happen to be the loan sharks of the Indian

subcontinent. Miss a payment and they break your legs.

I found some vegetarians who will not eat anything with a central nervous system. Some claim to have actually heard a carrot scream. I do not judge these people. I'm a scientist. Except for seafood restaurants where they showed me the live lobster that I was about to eat, I must admit that heretofore I had ordered food assuming that there were hamburger trees, chicken plants, and veal bushes. That was before my study.

The toughest thing for Peace Corps volunteers in undeveloped countries was having to slaughter their own food. When I heard that, I decided to record my own feelings as I myself personally killed things. You know, to better understand the emotional involvement that killing brings forth. I snuffed out higher and higher life forms. Stepping on an ant had never meant anything to me before, but this, this was different. I sailed through the most primitive life forms: amoebas, mosquitoes, worms, snails, crustaceans, and even a mollusk. Then a spider, a butterfly, and my first mammal, a squirrel. I scientifically monitored and recorded my emotional and physical responses to having actually killed each creature personally: my heartbeat, pulse, temperature and so on.

Word of my work got out, and I appeared on the Geraldo Rivera and Montel Williams TV shows in the same week.

I even got lucky. George Bush and John Sununu must have seen the shows because I was invited to go quail hunting with them in Texas. It was quite enjoyable. The flutter of wings and BOOM! Feathers everywhere. Then I went deer

hunting with Rush Limbaugh. We both bagged our bucks without ever getting out of his car. At least mine was a buck, a big twelve pointer. Limbaugh's looked like a little doe. He said his first shot must have blown the antlers off it. Anyway, we tied mine to the fender and thought it would be better if we put his in the trunk while we drove back to New York from Michigan. It was probably the highlight of my research.

But then, as I expected, the killing got more personally involving. A stray cat... unpleasant. A neighbor's dog... even more unpleasant. A chimp?... impossible at this particular time. A dolphin?... even more impossible! I studied films of Japanese fishermen doing it.

And now the time has come, as I knew it would... time for a human being. You see, I will have to kill an actual human person if I'm serious about earning my doctorate. And I am, you know. I've been able to chart my emotional responses to being responsible for every one of those animal deaths. Look. See? I've made this graph. You see, right about there. It became easier. My reverence for life ebbs and flows, doesn't it? See that? Right there is where I had a little problem doing certain things. And right about here on the chart I think I got a little callous. But not really. I wouldn't have skipped the chimp and the dolphin if I had become callous. "Indifferent" you might say, but don't misunderstand. I never enjoyed it, really, any of it. Listen! By the time I got to the point of eliminating a human example, I thought to myself, "Why not choose someone the world would be better

off without?" Yes! It should be someone that deserves it, don't you think? You know, if I would have wanted to kill the rotten son of a bitch anyway. What do you think ?... You look drowsy, asshole. I must be boring you... would the subjective element of me *personally* choosing someone to eliminate negate my scientific conclusions? I'd appreciate your help on this, shithead. Here, let me freshen up your drink while you're thinking about it. I'll return directly, stupid. I have to get something in the cellar."

❋

God has made it perfectly clear that he intends to punish the
intelligent and curious and reward the frightened and gullible.

RANDOM

RAMBLINGS

HIRED HAND

Elmer Furrow didn't mind getting up with the chickens, but he hated sleeping in the coop with them. And if stepping in shit meant good luck, he was sure to win next week's lottery.

❁

"Christ died for our sins," preached Hiram Tyler, "so that means we can all start over."

❁

JOHN SMITH

He was known only as 083-24-9218 in bleak surroundings with bad food, brutal regimentation, and inhumane treatment in an institution that was calculated to break him both physically and mentally. In short, he was married and had a job.

LOVE NOODLE

Knute Knievel was standing at stud in a singles bar when he felt a twinge in his Love Noodle. He was so horny that he actually had started to glow in the dark.

He just couldn't help but wonder why all the women there feigned disinterest in him. After all he had just gotten new elbow patches on his corduroy jacket and he was certain he looked real snazzy.

✳

God loves the poor, but he loves the rich more.

✳

THE SPORT OF KINGS

It's hard to imagine the trauma a thoroughbred yearling goes through in his first real race. After being pampered and catered to and treated like royalty all your life... you're running around in a circle with a bunch of your friends and some little guy in a funny outfit on your back starts hitting you with a whip—hard!

SPELLBINDER

So sure was Senator Dornan F. Novak that he had won the televised debate that he opened up the meeting to general questioning: "If anyone here think I be wrong, stand up and let yourself be heard, YOU TREASONOUS SWINE!!"

❋

H.R. 'BOB'

H.R. "Bob" Ballpene was sitting in his camper reading *In Search of Excellence* when an oppressive dissatisfaction with his life descended on him. Out of nowhere it came, but why?

To all outward appearances it seemed he had everything a man could want. He was proud of each and every tattoo on his body, he loved the way he looked when he shaved his head, which was every other day, and though he was no Mensa he did have the alphabet down pat, and could tie his own shoelaces if given enough time.

It had taken him two years to do it but he felt it was worth the effort. His Dodge camper looked exactly like a log cabin—chimney, shingles, flower pots in all the windows, and it even had a little porch in the back. If it weren't for the wheels you'd swear you were in Switzerland.

❋

Bjorn Toulouse — the name of a short Swedish artist

THE SPEECH

President Ronald Reagan got his speech to the United Nations mixed up with the one he was to give to the American Legion the next day.

Certain phrases did not get the response he expected. "In the greatest nation on earth, with the finest fighting men the world has ever known..." he began.

The 120 ambassadors were puzzled. Each one wondered why he would single out *their* country and *their* soldiers for this generous but well-deserved tribute.

※

A hundred years ago, do you think you could have convinced anyone that today we would honor as a creative genius someone who cut off his own ear and gave it to a hooker?

※

Mother Theresa just bought a home in
Martyr's Vineyard.

※

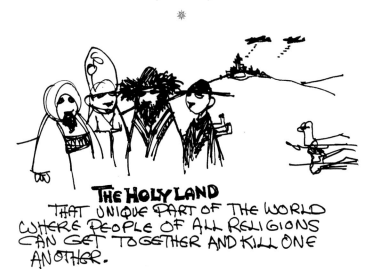

THE HOLY LAND
THAT UNIQUE PART OF THE WORLD
WHERE PEOPLE OF ALL RELIGIONS
CAN GET TOGETHER AND KILL ONE
ANOTHER.

If the Apaches, Mohawks, and Cherokee Nation had invented gunpowder first and learned to paddle the "Big Canoe," Europeans would be living in wigwams today and the Eiffel Tower would be just a big teepee in Paris. It would be made of saplings and Louis the XIV would have been known as Big Chief Crepe in the Face.

❋

No Canada or jail
for J. Danforth Quayle.
A call from his daddy,
he was replaced by his caddy.

❋

My father had a great sense of humor. When I was twelve years old, looking out over the San Fernando Valley, he put his hand on my shoulder and with a sweep of his arm said, "Son, someday all this will be yours." The next day he filed for bankruptcy.

Recently discovered El Greco study after Leonardo da Vinci

The British Admiralty has just released files from WWII hinting that submarine crews with the best survival rate in the German Navy were gay. Apparently late in the war a new technique of spotting U-boats from the air was developed. After being at sea for over six months, heterosexual crews were so horny that the subs exuded a testosterone aura that could be easily spotted at depths of as much as twenty fathoms.

※

Penguins don't sing, won't build a nest, and can't fly. What gives them the right to go around calling themselves birds?

※

Self denial is out of style.

※

If there were no God it would still be necessary for mankind to invent one so that they could take sides in order to kill one another in order to prove something or other.

※

The *Titanic* and the *Lusitania*—two ships that didn't pass in the night.

CHAPTER 11

Billy Sol Boesky was not pleased in bankruptcy court when his creditors agreed to settle his debts for ten cents on the dollar. "My God," he thought, "Who has *that* kind of money?"

※

To err is human, to forgive is out of the question.

※

"If there had been no Jesus it would still have been necessary to crucify him."

—Pontius Pilate.

※

She blew my mind, which was about three feet north of what I was hoping she would do.

※

The Caucasian's lament: "It ain't easy being cream."

※

Gone With the Wind, II

Is there anything less needed than the "chilled salad fork"?

✳

The research lab would not seem the same without Professor Waldstein. How could a brilliant man, who could see the universe in a grain of sand, not see the "Bridge Washed Out" sign?

✳

At a Republican fundraiser at which Richard Nixon was the guest speaker, Mrs. Jerry Falwell said, "I like Dick."

"Really," answered Reverend Falwell, "I love Bush."

✳

Ecumenical Council

Mathew, Mark, Nate and Al

"Conscience doth make cowards of us all," especially when it's backed up by a stiff prison sentence.

※

John Wayne was explaining to Audie Murphy how a *real* war hero should act out his bravery on the screen when Murphy became ill and had to excuse himself.

※

President Andrew Jackson owned 200 slaves. They were reported to have been grief stricken when he died suddenly in 1848. They had hoped he would suffer a long, lingering, painful death.

※

Occasionally I realize that of the hundreds of people whose lives I envy, there are, in reality, probably only two or three that are doing as well as I am. I must find out who they are, so that I can outdo them.

※

Blessed are the peacemakers... but watch them closely.

※

Only the simple-minded believe that ignorance is bliss— which makes it absolutely true.

John Wilkes the night watchman knew the law. You can't yell "fire!" in a theatre.

True, it did burn to the ground, but he didn't write the laws, he just obeyed them.

✵

Lord Byron died in 1828 fighting for Greek Liberty. Actually, he was stricken down by fever at Mesolóngion so it might be more accurate to say he died *of* Greek Liberty. It has not been reported whether the Greeks ever got it. Liberty, that is.

✵

Bjorn Borg was bjorn in Gstaad ingstead of Gdansk as many people have wrongfully gduessed.

✵

In 1974, while narrating a *Wild Kingdom* TV show on the attention span of the otter, Marlon Perkins fell sound asleep.

✵

No shark has fallen asleep for the last 170 million years. They must be exhausted.

✵

Silas Moran looked up to Toulouse-Lautrec— which wasn't easy.

A SHOT RANG OUT

"Brevity is the soul of wit," chuckled H. L. Menfo. "And there are ten reasons *why* brevity is the soul of wit. Part *A* of reason number *one* is..."

✻

Randy Ready is an infielder with the Philadelphia Phillies. If he were a catcher for Doc Gooden with the NY Mets they could have a battery made up of Gooden, Ready.

✻

Cowards die a thousand times before their deaths, a brave man but once *and* prematurely.

✻

Edgar Degas, the great French Impressionist, looked down on Henri de Toulouse-Lautrec. But, then again, so did everyone else.

✻

I want to make you feel good about yourself. You know more about the Universe that Leonardo da Vinci did.

✻

Dr. Solomon had to put his Blalock press away and cut his pain threshold experiments short. The screams of the laboratory chimps were giving him a headache and he was out of Tylenol.

✻

Howard Stern has made me laugh but he's not funny.

❋

My priest claims that celibacy is a gift from God. Well he got
me that last year. Now how about the gift of pussy?

❋

Accepting constructive criticism is surely an indication of a
creative mind. So I was especially pleased to be present at the
banquet when Benny Hill chewed out David Lean for his fre-
quent artistic lapses when directing the movie *Lawrence of
Arabia,* which, of course were apparent to those of us who saw
it twice.

❋

"Can you describe H. Ross Perot?"
"Put ears on a hand grenade."

❋

*The early vote count indicated that Monsieur Ettienne Hobble had
become the first "lame duck" mayor of the city of Lourdes.*

THE BLESSING

"Oh kind and merciful God," sobbed Orvil Parks, a busboy on the *Lusitania.* "In your infinite grace and kindness, you have spared me from this awful..."

He had to cut his prayer short, the bodies washing up on shore made kneeling in the sand difficult.

✳

"He who fails history is bound to repeat it!" This was not philosopher George Santayana. This was Mrs. Richardson and she told me this in the eighth grade. She was right. I had to repeat it, or I wouldn't graduate.

✳

I do not believe entirely in the science of cryogenics but I did put my mother in a freezer at Haagen Dazs because I knew it would have pleased her.

✳

Alan Dershowitz is working on a new book about the Jews for Jesus movement. It's called *Reversal of Foreskin.*

✳

My horoscope informs me that I am attracted to Pisces with big tits.

✳

You know your diet is wrong if you have to use an air freshener after you take a leak.

<p style="text-align:center">✻</p>

Seattle, Washington, has the least amount of street crime in the United States because it never stops raining there long enough for anyone to go outside to be robbed. And there are no homeless because most of them have dissolved.

<p style="text-align:center">✻</p>

<p style="text-align:center">✻</p>

<p style="text-align:center">The main feature of the guillotine in
capital cases—accuracy!</p>

<p style="text-align:center">✻</p>

DEFINE YOUR TERMS!

"Very well, by ten-to-twenty I mean you won't be doing any traveling, bar hopping, girl chasing, or much of anything else for the next decade or two. And if you're bad and won't let the guards have their way with you, or complain about the system, the food or the harsh treatment, well sir, that means you won't get out while you're still breathing!"

"Thank you, Your Honor, I just wanted to make sure I got it right."

DIFFERENT STROKES

Jack Hoff's patent search had yielded disappointing results. But he was not discouraged. He was quite aware that if he *were* to receive a one cent royalty on masturbation he would be the richest man in the world. And, with back royalties plus penalties, he would be the *only* rich man in the world.

❋

When he was fourteen years old, Elmer Young discovered the pleasures of whacking off. When he was eighteen years old he decided to try it on himself.

❋

DAIS

Chaos spoiled the "International Conference on Human Understanding" at the United Nations.

The Secretary General introduced "the leader of the greatest nation on earth..." and the rostrum collapsed as 137 speakers approached the microphone simultaneously.

❋

"Nanookie of the North"
Famous Eskimo pornographer

1954

It was the worst of times and it was the worst of times. At least for Luke Silo, the Utah rancher—and with good reason. In one night, 12,000 of his sheep died of heart attacks.

At least that's what the Defense Department said in their report.

Luke read the report easily because he glowed in the dark. He considered this a plus because his electric bills had been higher than usual lately.

※

PRIDE

"Buzz" Kurowski wasn't the only one in Appalachia who was shocked at the Reagan Administration's ruling that there was no such illness as "black lung disease." But he was so proud of the invasion of Grenada that the inconvenience of filing his absentee ballot from his oxygen tent was well worth the effort.

※

This was certainly not what Lot expected to see when he looked back. His wife has turned into a pillar of freshly ground pepper.

SACRAMENTO, 1942

"The crime of silence must end," roared California State Senator Seymore Yallowitz. "Jail those Jap bastards!!"

✳

Ernie Pyle, Robert Stack, and Danny Heep all loved Peter Paul's Mounds.

✳

When Patrick Henry shouted, "Give me liberty or give me death!" you can bet he was out of earshot of his slaves.

✳

I get a little chill when I think that G. Gordon Liddy was an FBI agent investigating other people.

✳

It's a funny thing. When I was a kid I hated getting spanked. Now I kinda like it.

I have been to few events where I *really* want to return after intermission.

❋

There is nothing like a Christmas carol beautifully sung to make the melancholy of the nonbeliever all the more excruciating.

❋

Here is proof, that in art, unlike music, there are no child prodigies.

Mozart symphony composed at age six.

A page from Rembrandt's sketchpad, age twelve.

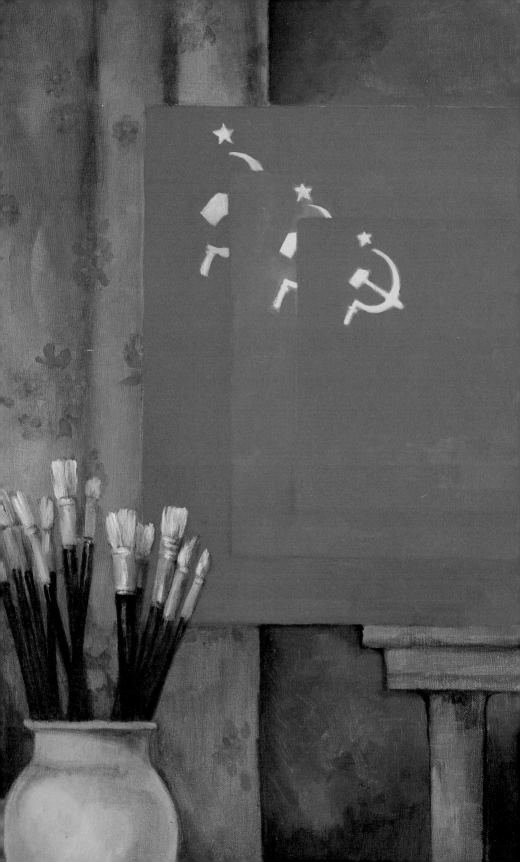

POINT KILLER

NIGHT

❋

Midway between the community center and city hall in Swamp Knob, West Virginia, was Half-Way House. Mark Twain had inadvertently called it *'Half Wit'* House in 1906. He was passing through town and sat in on one of their town hall meetings. The name just seemed to catch on for some reason.

There was a strong sense of community in Swamp Knob and Half Wit House's Meeting Hall was always abuzz with activities — Monday was "Misquote Night." The Tuesday meetings of the "False Assumption Society" and "Go Fuck Yourself" clubs were for gentlemen only. The "What Ifs" were open to the general public but only met once a month.

Light traffic, empty bars, and deserted streets meant it was "Point Killer Night" at Half Wit House. This always assured a standing-room-only crowd of the intelligentsia in the Oaf Room.

"Let us begin," the instructor said, and recognized the first speaker.

"I AM SOMEBODY!" shouted the black man in the first row.

"Who isn't?" the instructor shot back. "Next."

"How can the United States, the richest most affluent country in the world, not take better care of its sick and elderly?" asked a ninety-three-year-old woman from her gurney.

"If you like Russia so much why don't you go live there?" the professor asked.

After the applause died down he recognized the next speaker.

"In the name of a balanced foreign policy in the Middle East, the United States should not give intercontinental nuclear ballistic missiles to Israel."

"What about Auschwitz?" yelled Mr. Beckerman. "Look at these tattoos!"

"That's what it's all about," the beaming instructor said over the cheers. "Next."

"You can't shout 'Fire!' in a crowded theatre." announced the next speaker, Swamp Knob's only ACLU member.

"Oh sure, just sit there quietly and let everyone be burned alive," responded a Young American for Freedom.

"Excellent! Excellent!" praised the teacher and recognized the next speaker.

"No man is an island!" stated an Orson Welles look alike.

"What did he say?" asked a man with a hearing aid.

"Norman is an eyelid!" answered a man without a hearing aid.

"Nomads are in Ireland!" corrected the instructor. "OK. Next!"

"Jesus Christ died for our sins," intoned a sincere young man.

"Didn't he have a middle name?" asked the teacher.

"Christ died for our sins!" the young man repeated.

"Gee, what a nice guy," added a teary-eyed young blonde.

The night's celebrity speaker, astronomer Carl Sagan, stated to the throng in profound tones that "The universe is expanding!"

"So am I," shouted a fat slob in suspenders and a Pendleton shirt.

A Sierra Club spokesman confidently took center stage.

"Our national debt is $438,000,000,000. That's *four hundred and thirty-eight trillion dollars,* people! Think about it. That debt has hamstrung the United States government from the expansion of ecological concerns that could thereby improve the quality of life the world over. Think about it."

"How about what we did to the Indians?" an honor student countered after thinking about it.

"Hey, let's not change the subject," said the instructor with a wink and a sly smile. "Next!"

A Greenpeace activist said, "We must stop the indiscriminate slaughter of the blue whale!"

"Sweden has done that. And they have more suicides than any other country in the world," countered the only Rhodes scholar in attendance.

"Well said, young man! Next speaker please."

"I believe there is a just and vengeful God," said the Reverend Tyler.

"Then what's he waiting for?" questioned the manic depressive sitting on the windowsill.

Reverend Tyler continued, "You can ask God for anything."

"How about an apology?" asked a sarcastic blind man in a wheelchair.

"The Lord works in mysterious ways." Tyler added.

"Who doesn't?" countered a tall elderly agnostic. He continued, "I firmly believe in the separation of church and state."

"So does Fidel Castro, you communist bastard," the good reverend shouted.

"YES!!" The instructor said, beaming with pride. "You are truly a man of God."

"That's my point," said the agnostic.

"Never mind that kind of talk, pinko. We're here to *kill* points not make points. Don't spoil the whole evening for everyone by making one."

Before dismissing the crowd, the professor made an announcement to the packed auditorium. "I am so proud of each and every one of you. I look forward to many more of these wonderful evenings. Our next meeting will be here at Half Wit House next Tuesday at 7:30."

"I can't make it," called out a woman in the back row.

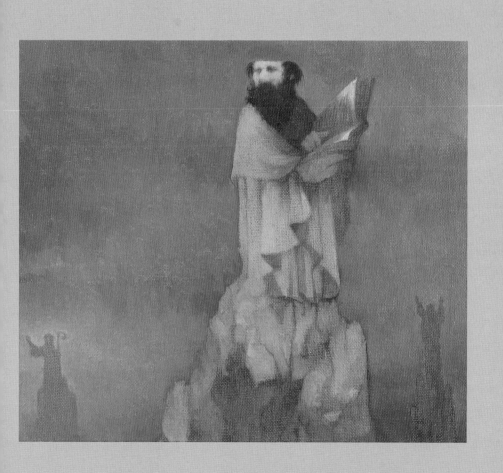

I THINK, THEREFORE I AM, I THINK

ART HEAVEN

✸

Here I am, at last. I've been dead about twelve years now, and I'm not exactly sure if I'm going to be getting into this place. I was instructed to bring my portfolio with me. The registrar who skimmed my resumé said I shouldn't have anything to worry about. I've never painted on black velvet. I've never painted a montage of the highlights of Joe Montana's career, and many of those pictures of the little homeless waifs with the huge eyes were painted by someone else.

Seems like I've been here forever. The line doesn't seem to have moved much since I first got here.

"I wonder who's in charge here?" I thought to myself.

"Don't you worry yourself about who's in charge here, baldy," said a voice that I accepted as being aware of my thoughts. Things like that happen up here.

"Well, I just wondered who I'm waiting for, that's all."

"Rembrandt! Velasquez! Goya! Titian! Ever heard of them? That's who you're waiting for. You have your portfolio? They are going to judge you by your portfolio."

I knew instinctively what the voice meant. Every artist has his own version of Art Heaven. Mine was a place where all

the great creative artists of the past would all be together like a sort of extended family. They would have picnic lunches and wine tastings, and talk about art and poetry, beauty and eternity, music and great literature. Forever! The best part would be that they'd treat me like an equal! But, my God— Rembrandt? Velasquez? Goya? Titian? Judging me? Judging my work? The art director at Simon and Schuster didn't even like my stuff for Christ's... for goodness sake... But wait... I was a fairly good person. I mean as a human being type person that is. Maybe they'll give me extra points for that. If they don't, I'm fucked. I wondered to myself just what the qualifications for entry were. "Could it be talent?"

"Of course."

"Skill?"

"Yes!"

"Dedication?"

"Usually. Let's just say *perhaps* on dedication."

"Really?"

"Yes, very many were dedicated. Dedicated to booze, drugs, and the high life in general. Many achieved just a fraction of their potential."

"Integrity?"

"Integrity? Ha! You must be joking."

"I'm not. Why do you say that?"

"When dealing with creative people, the term integrity is used only by people who write about them. Fame, money, and beautiful lovers were what the artists themselves were interested in."

"Is that bad? If it is, I don't have a chance."

"Not at all. It's just that, up here, bullshit doesn't go as far as it does downstairs."

"Give me an idea of how they judge things. Like did Andy Warhol get in?"

"Just for his fifteen minutes. Ha ha ha ha."

I decided I'd better stop thinking. If I didn't, they'd find out the only reason I wanted to be an artist in the first place was so I would get to draw naked women.

I wandered down the halls, and peeked into the studios.

Peter Paul Rubens was sharing a studio with Erte. Miraculously, they were using the same models.

Jan Vermeer was in a darkened room using a camera obscura to trace a picture on a canvas. That's cheating. But, geez, look at those paintings. I wish I could cheat like that.

Down the hall, Marc Chagall was beating the shirt off of Edgar Degas. Degas, though barely conscious, still maintained that Colonel Alfred Dreyfuss was guilty. Chagall was using an ancient Talmudic method of debate on him to convince him otherwise. Why are these two together in the same studio? An anti-Semitic master draftsman matched up with a naive painter of Jewish folklore.

It's an interesting pairing when you stop to think of it. If that's the kind of decision they make up here, I may have a shot at getting in after all.

In an adjoining studio, Salvador Dali and Hieronymus Bosch were questioning Norman Rockwell about his fabulous imagination.

El Greco, who stood 6′6″, shared a studio with Toulouse-Lautrec, who was 4′8″. Their perspectives of the world certainly had an effect on their work. El Greco painted saints and saviors, noblemen, and popes. Toulouse, from his vantage point down below, specialized in brothels, hookers, cancan dancers, and saloons. A fourteen-piece orchestra played as they painted, just as one always had played for El Greco in his studio when he was the toast of Toledo. Toulouse did not complain.

I roamed the halls and peeked into some of the other studios.

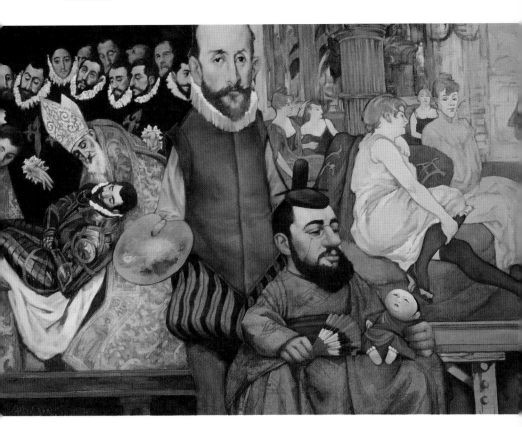

Incredibly, Michelangelo was in limbo. The notice on his door stated he would not be admitted into Art Heaven until he proved he could paint a person wearing clothing.

At this stage of my visit, judgments like that were starting to make sense to me.

Ironically, Daniel da Volterra—the artist that Pope Innocent XI hired to paint draperies over all of the nudes in the Sistine Chapel in 1637—is a full-fledged member here.

I had expected that Paul Gauguin and Vincent Van Gogh would be sharing a studio in Art Heaven. But no. They had to be kept separated. I overheard Gauguin shouting, "Keep that maniac away from me or I'll cut off his other ear. He's a fucking lunatic!"

I sympathized with Gauguin. I read that as a novice priest, Van Gogh preached to poor people in the slums of London that poverty was good, hunger was purifying, and pain was a gift from God. He had a very small congregation. It's hard to believe, but Van Gogh sold only *one* painting in his lifetime. I wonder if the guy who bought it is up here. If he is, I'd like to show him some of my stuff.

A very raucous Frans Hals, and a half-tanked Modigliani were reeling around their studio, toasting the birthday of Maurice Utrillo, who had already passed out cold in the corner. They would both be joining him there soon.

Hey, I might fit right in here.

I continued down the great corridor, past the workplaces of the great masters.

I peeked into Caravaggio's studio. He painted his sublime

masterpieces around the year 1600, and some consider him to be the first "modern artist." As a young student, his work had a great influence on me. I quietly watched him work. What furious, confident brushwork. No underdrawing. No sketches guiding the work. Incredible! He just attacked the blank canvas, and the figures appeared like magic under his brush.

He was a dark handsome man. Swarthy with a heavy beard and a muscular, hairy physique. He put his brushes down. He was slipping into a lovely pink tutu when he noticed me.

"Will you help me zip this thing up?" he said in a very, very high voice. "I just hate being late. Don't you? Don't just stand there, silly, hand me those ballet slippers. Leonardo's going to show us some of his new discoveries tonight."

"Is it a costume party?" I asked.

"Costume party! Why you bald son of a bitch," he snarled in a much deeper voice. He pulled a dagger from his sash and reached for his sword.

Holy Toledo! I suddenly remembered. Caravaggio was a brutal violent thug. A great artist, but a violent thug. He killed his best friend over a single point in a game of tennis. I didn't know he was a cross-dressing fruitcake too. Could that be? You just don't expect that from such a great artist.

Gee, if they let *him* into heaven how could they keep *anybody* out?

Caravaggio's dagger whistled past my ear. I shouldn't have been surprised. How could anything hurt me up here?

"How did he get in here?" I wondered.

"Never mind that, dickhead." It was the voice again.

"They're waiting for you. Try not to embarrass yourself."

At this point, I'd like to tell you plain and simple what happened, just as it happened.

I opened my portfolio and spread my work out on the huge table, to what I thought was its best advantage. Small pieces first. Then the larger, and... oh look at that! What made me think that one was any good? Bad drawing... careless painting. I hoped they wouldn't notice. And then they came!

Rembrandt, Velasquez, Titian, and Goya walking straight towards me and my disgusting work. I was getting nauseous. I felt faint. They passed me as if I weren't even there. They headed directly to the table. They were looking at my work. They were exchanging "glances of doom." At least that's what it looked like to me.

Rembrandt spoke.

"How badly did you need money when you painted this?" he asked, holding up a picture that I was ashamed to have painted, and even more ashamed to have signed my name to.

"Very badly, Your Greatness and Highnessness." I was babbling now. "A car payment! Rent! Taxes! I'm not sure. Maybe food." To myself, "Why doesn't someone kindly shoot me?"

Rembrandt looked pleased. "Yes, rent and food. I thought so. Look at the panic in those brushstrokes. The desperation. I've been there myself. I know just how you felt."

"How old were you when you painted this?" asked Titian.

"Thirty-eight," I guessed.

"Ha! Nothing! I died at ninety-nine years of age. What a shame. It made me sad. Do you know why, young man?"

"No, Your Sublimeness, why?"

"Because when I was ninety-nine years old, I was *just* beginning to learn how to paint."

"AHA!" I was suffering a severe brain cramp. "Aha!" I repeated with even less meaning.

Titian smiled a ninety-nine year old smile, as if he knew what I was driving at. I thought to myself, "He likes me. Rembrandt has made up his mind. I can tell. I think I got him with the money thing."

It was time to try to strike some Hispanic chord with Francisco Goya and Diego Velasquez. "I loved reading *Don Quixote*. It's a great classic," I said. "And I think Cantinflas was the funniest comedian ever. Don't you?"

"He stunk!" said Goya.

"You know, you're right. He never really made me really laugh... you know, out loud or anything like that, I mean..." The brain cramp was returning.

"*Don Quixote* was too long," Velasquez said, staring at my worst painting.

"Well, I never actually read the whole thing. I mean, who has that kind of time? You know, page after page. It just seems to ramble on and on doesn't it?" Grovel, that's it, grovel. Oh God, I was losing them.

"What's the title of this one?" Goya asked.

Oh, Oh! Trouble.

"I call it *In the Beginning There Were Mistakes,*" I said.

"Is that supposed to be God?"

"Yes."

They all gathered around the picture.

"You see, I have painted God at the very beginning of Creation when he really hadn't decided yet how anything should look."

"Is that why there are breasts on that tree?" asked Velasquez. "And reptile tentacles where the roots should be?"

"Ha! And God looks kind of dopey and bewildered."

Rembrandt added, "Wait'll we show it to him. He'll love it."

"That's funny stuff, kid," said Titian. "Not very well painted, but funny. I like it."

"Just like in all the museums back home, laughter is a rare thing up here," said Rembrandt. "Fellows, it's April Fool's Day. Let's let this fellow in just for the fun of it. As our little joke on the Big Guy himself."

They agreed and that was that.

Well there you have it. They did pass me right on through. Can you believe it? I'm not sure I got in for the right reasons, but here I am. Art Heaven! Say what you want about artists being self-centered and all that, but when it comes to empathy, I think they're just about the best there is.

※

Now that I've been accepted as an equal up here in Art Heaven, I'm going to start asking some of the tough questions.

For example, Mark Twain and I both want to know why Titian didn't pass up a few saints and popes, and paint a portrait of William Shakespeare. A few paintings of martyrs wouldn't be missed if we could have had *one* real likeness of the Immortal Bard.

Titian was alive when Shakespeare was in Italy writing *The Merchant of Venice*. Why didn't he... wait a minute. I don't think Shakespeare ever set foot out of England... and Titian never left Italy. OK, well then I'll ask Hans Holbein why *he*

didn't paint Shakespeare. He was the Royal Court Painter at Buckingham Palace and... hmm... that's no good either. He died 100 years before Shakespeare was born. But that's not the point. The point is why didn't *anyone* paint Shakespeare? We have portraits of blacksmiths, coopers, tinkers, groundskeepers, and every nonentity of those times but no Shakespeare!

There must be a Writer's Wing up here. Maybe I should just walk over there, introduce myself, and ask him myself. That is, if he's up here. It's very possible that if he talks like he writes they didn't understand him enough to let him in. Ezra Pound has been in the waiting room here for thirty-seven years. They still can't figure out what he's driving at.

Something else has been bothering me that I must clear up.

Amsterdam, Holland, in the 17th century was a wonderful place to be an artist. Just about the best ever. Money, money everywhere, and blank walls to be covered here, there, and elsewhere. There is no controversy about this.

It is also known that the great Rembrandt, Amsterdam's wealthy and respected master would, in disguise, bid on his own work at art auctions. You know, to drive the prices up. Let us try to picture that. The great Rembrandt van Rijn appearing, as has been reported, on this particular occasion as a young woman. The work on the docket? Perhaps the greatest etching ever done, his *Hundred Guilder Print.*

"Sixty guilders!" says she (he?), making an aggressive overbid.

The auctioneer raises his gavel. "Sixty guilders! Do I hear seventy guilders?" He stops, pauses, poses gavel in midair... pauses again... and... "Sixty guilders once...? Eighty guilders!!! Thank you, Rabbi... Eighty guilders! Do I hear ninety?... Ninety??... Eighty guilders once, eighty guilders twice!... No other bids? Are we done?... No other bidders?... Ninety?... Ninety??? Thank you, sir. **One hundred guilders!!! SOLD!** To the good gentleman in the corner!"

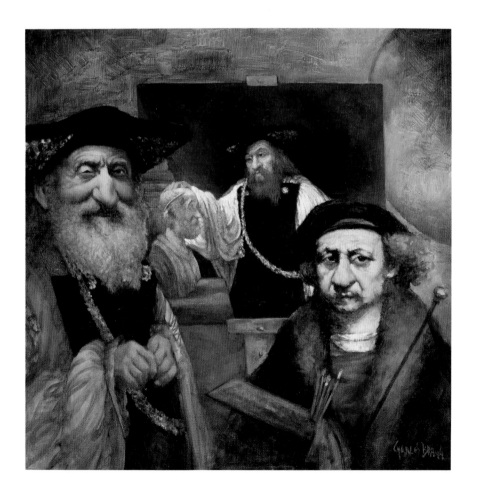

The winning hundred guilder bid on the *Hundred Guilder Print* has come from an elderly bearded Jew sitting in the same general area as the young girl who had made the opening bid. He has a skirt around his ankles.

Understand that this happened a long time ago and eye-witnesses are expensive. True or not, the feeling of many is that Rembrandt's aggressive bidding at art auctions just such as that one caused him to finally descend into bankruptcy. An amazingly similar thing happened to me. The bankruptcy part, that is.

I can't wait to talk to him about this. Up here in Art Heaven we're equals now, Rembrandt and I. We have so much in common we'll probably be hanging out a lot together.

※

There's not as much music up here in heaven as I expected. No harps or organs. No bands of heavenly hosts or singing angels. You'd expect hymns and carols sung nonstop no matter what part of heaven you were in. No Hallelujah chorus or Gregorian chants. I can't say I'm disappointed. No offense, but a little of that goes a long way with me.

Now that I'm up here, I think I'll meander over to the Music Wing and see what's shakin'. You know, with Beethoven and Mozart and the other cats. I wonder if they hang out together. Do you think Salieri is up here? If the Big Guy saw *Amadeus,* he isn't.

I've got to talk to Mozart. Writing symphonies when he was six. Can you imagine that? At six I was just learning to

wave bye-bye for God's sake. So many great musicians were phenomenally gifted as children. I remember reading that Niccoló Paganini came very close to being buried alive when he was a child. He was already given up, anointed, and wrapped in funeral shrouds just moments short of burial. As the coffin lid was about to be sealed, someone noticed a twitch, a sort of tremolo in a tiny finger. Then movement in another, then another. Almost as if he were playing the violin. Then a cough. He was breathing. Four years old, in a tiny coffin wrapped like a mummy back from the edge of death, and his little hands are playing an imaginary violin. Can you imagine that? Miraculous! It was a very close thing. I wonder if he remembers any of that. I'll find out. I'm sure he's up here somewhere.

In those days being buried alive by mistake was a very real possibility. That's why rich people had bells in their coffins. Frederic Chopin was so haunted by that possibility that he left instructions that he was not to be buried until surgeons had cut him entirely in two. When he died, his instructions were carried out. And his heart was sent to Poland, his homeland. Chopin was buried at the age of thirty-nine. There was no doubt that he was dead.

What's that I hear, as my guide and I near the Music Pavilion? Oh this is surely heaven. It's Pachelbel's *Canon in D*.

"Don't get all choked up. They never *stop* playing it," said my guide and the man who wrote the lovely melody for the *Star Spangled Banner*. "It's been playing for eighty-six years straight now. That and Ravel's *Bolero*."

"Eighty-six years? Is it some sort of punishment?"

"For him it is."

"Who is that?"

"Richard Strauss, the German composer."

"The man who wrote the music for my favorite movie, *2001?*"

"Well, sort of. It was called *Thus Spake Zarathustra.* He also wrote *Der Rosenkavalier, Salome, Ein Heldenleben, Til Eulenshpiegels Merry Pranks*—some of the most important music of this century. Masterpieces every one. Works of genius but that's beside the point. It turns out he was Adolf Hitler's Minister of Culture. We're talking Third Reich here. Those Nazi bastards called it 'Kultur' I think."

"But gee, I loved the music in *2001.* Didn't you?"

"Not that much. Can you imagine? They make a movie, *Amadeus.* It wins every goddam Academy Award known to man. All about Salieri being a little jealous of Mozart. Let me ask you this, who wasn't? And Richard "Fucking Nazi" Strauss. No movie, no trial, no nothing. They play his stuff like he never killed a Jew, for Christ's sake."

"I would expect Richard Wagner to be here too."

"He's here. But for him it's worse."

"Really?"

"Much worse. He has to listen to his *own* music."

"Oh God."

"Yes. The entire *Ring Cycle* with no intermissions for the next five hundred years. Five hundred years without letup. After which a recording of Jan Peerce singing *Kol Nidre* will

be played at him for the *next* five hundred. It may not be hell, but it's as close as we could come."

"You know, I would *rather* burn in hell."

"Who wouldn't?"

MEET THE AUTHOR

❋

It was "Meet the Author" night at Half Wit House. The author of this story was the guest speaker.

A fascinating question and answer period followed my speech.

"How come we, as the characters in your stories, say and do such stupid things?"

"Because that's what I decided you should say and do," I answered.

"Who are you to decide these things?" I had one of them ask.

"Because as the author of the stories, I can have you say and do whatever I want you to say and do."

I must have been looking for a fight because I had someone say, "What nonsense! That doesn't make *any* sense at all."

"It doesn't *have* to make sense if I'm writing the story, and that's what I want to happen," I said. "For example, your character—I can drop you from this story in a second if I want to."

"That's stupid."

"Kill him, Carruthers!"

"With pleasure, sir."

"Nice work, Carruthers. You see, now you're dead and

out of the story. Now I have to decide whether it was murder or self defense. Either Carruthers gets off Scot-free or burns in the electric chair."

"But sir..."

"I don't want to talk about this any more. Good night," I said as I left.

"Good night," replied whoever I decided I wanted to say it.

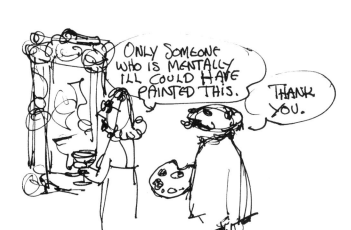